Stained Glass

Coloring for Artists

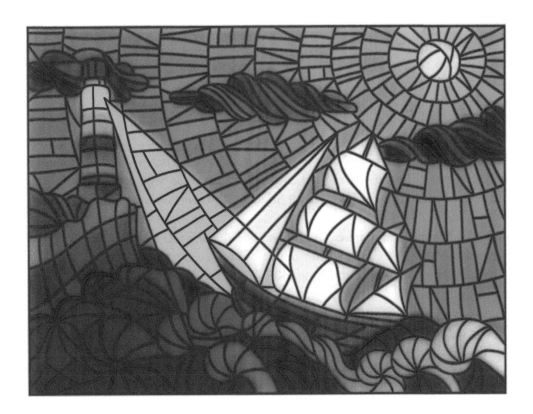

Skyhorse Publishing

Skyhorse Publishing books may be purchased in bulk at special discounts for sales promotion, corporate gifts, fund-raising, or educational purposes. Special editions can also be created to specifications. For details, contact the Special Sales Department, Skyhorse Publishing, 307 West 36th Street, 11th Floor, New York, NY 10018 or info@skyhorsepublishing.com.

Skyhorse® and Skyhorse Publishing® are registered trademarks of Skyhorse Publishing, Inc.®, a Delaware corporation.

Visit our website at www.skyhorsepublishing.com.

10 9 8 7 6 5 4 3 2

Cover design by Jane Sheppard
Cover artwork credit: Shutterstock/Zetta
Text by Chamois S. Holschuh

Print ISBN: 978-1-5107-1451-9

Printed in the United States of America

Stained Glass:
Coloring for Artists

Have you ever visited a cathedral and admired the intricate, colorful worlds to be found in its windows? Have you ever been drawn toward a deep purple vase or bright yellow garden globe? These lovely art pieces are made of stained glass, and the history behind them is fascinating. This adult coloring book will take you on a tour of beautiful designs, from flowers and birds to stars and abstract patterns. While the pages are only paper, all you need are colored pencils or markers to illuminate these designs.

Dating back to the Egyptians and Romans, the art of coloring glass has had a long and varied history. Earlier pieces were simple glass objects that had been stained, such as cups and vases. As the centuries rolled forward, artisans began experimenting with more advanced tools and techniques. By the seventh century, British churches and monasteries featured stained glass windows—hundreds of colored glass pieces set in lead. In the eighth century, the philosopher and polymath Jabir ibn Hayyan (born in what we now know as Iran) developed over forty methods to make colored glass and wrote about cutting the material into faux gemstones. By the Middle Ages, making pictures out of stained glass became popular, and the art form was often used to depict saints and Biblical narratives in church windows, a practice still widely seen today.

Beyond its prominent use in churches and mosques, stained glass has been utilized in government buildings, restaurants, and even homes. Various courts and capitols have massive stained glass domes, while many Victorian houses boast a feature window on a staircase or front

Moroccan designs are carved in these panes of stained glass, giving this window an extra flair.

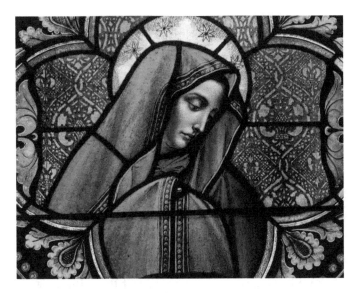

A stained glass depiction of the Virgin Mary in a stunning demonstration of rich colors.

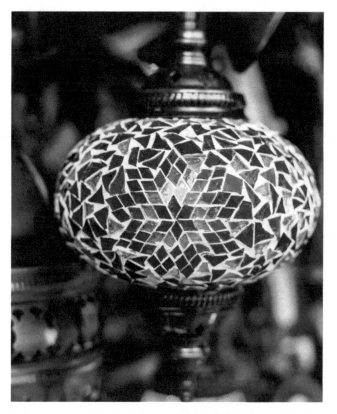

A lantern in a Turkish bazaar made of blue stained glass fragments, pieced together in a decorative pattern.

door. Ranging from ornate landscapes, family crests, and floral designs to simple diamond and abstract patterns, the medium has been realized in a multitude of ways. No matter the design, the effect of the sun's rays streaming through the colored panes, projecting bright hues onto interior surfaces, is a magical experience.

Indulge in the wonder of stained glass as you explore the pages of this adult coloring book. First, you'll find a set of pre-colored versions of each design to inspire your own creations. Next, you'll find a collection of forty-six black-and-white designs on one-sided, perforated pages. Pull them out for a more comfortable coloring experience, and put them on display when you're done. Use the color bars at the back to plan your masterpiece, or let your imagination run free. However you approach this coloring book, you're sure to find yourself lost in a world of beauty and grace. Color, and be at peace.

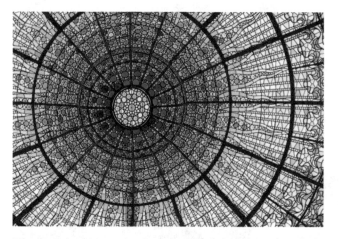

The breathtaking stained glass skylight of the Palau de la Música Catalana in Barcelona, Spain.

1

2

3

4

5

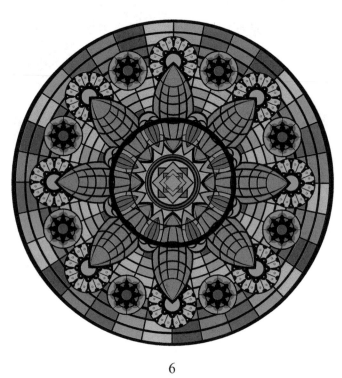

6

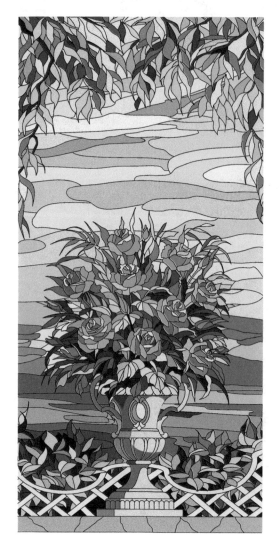

7

8

9

10

11

12

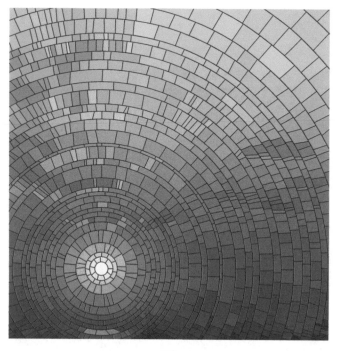

13

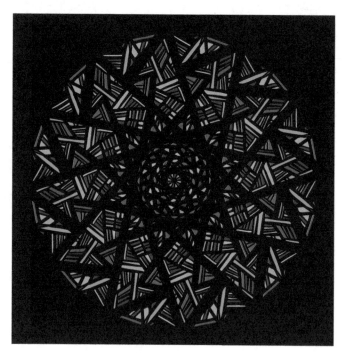

14

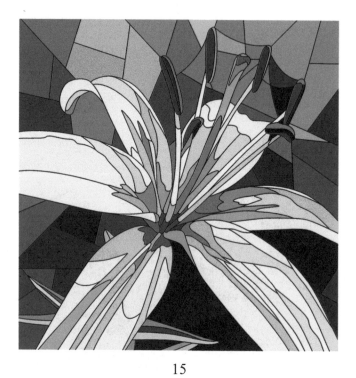

15

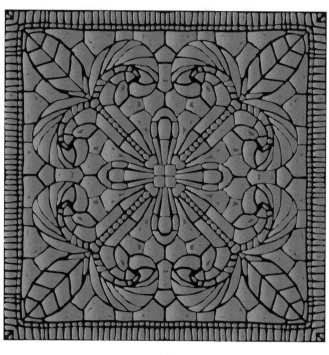

16

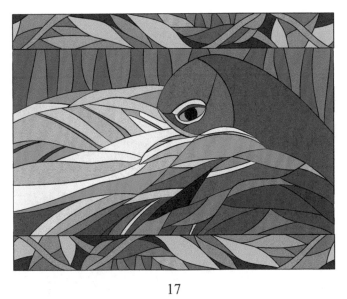

17

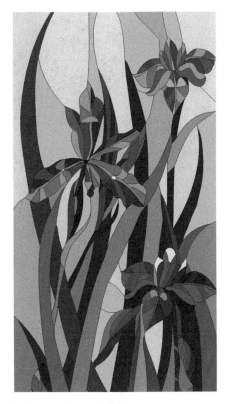

18

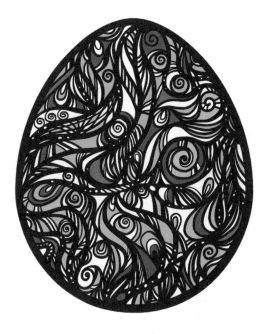

19

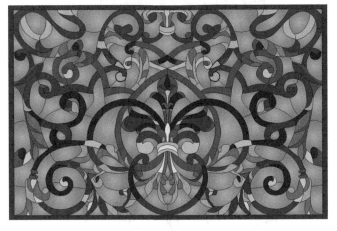

20

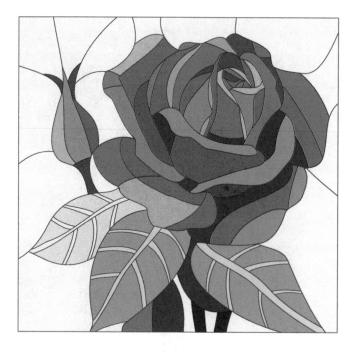

21

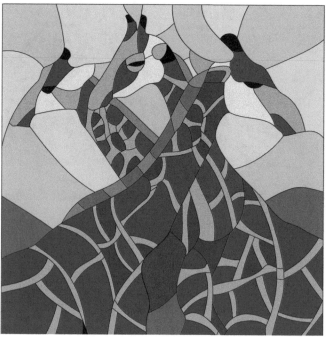

22

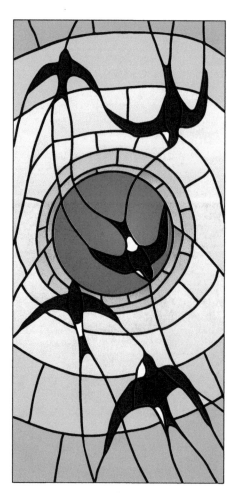

23

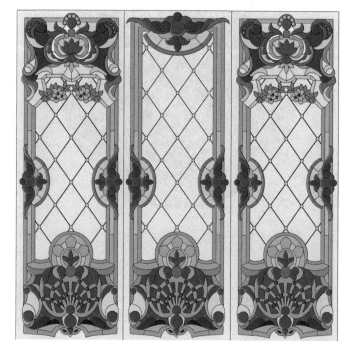

24

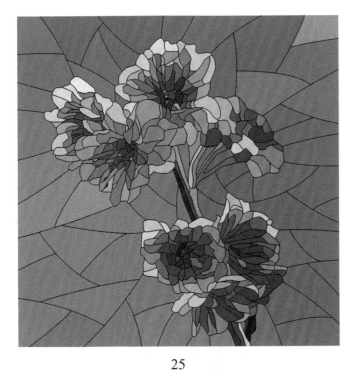

25

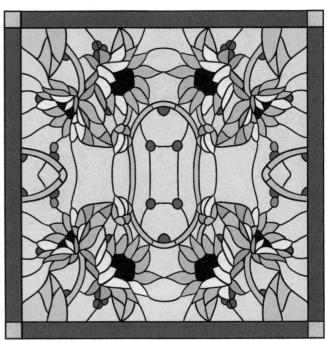

26

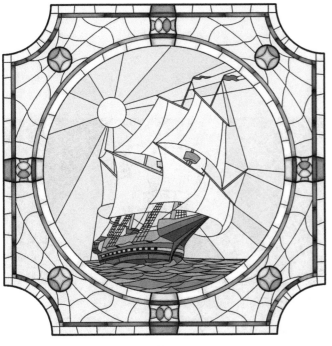

27

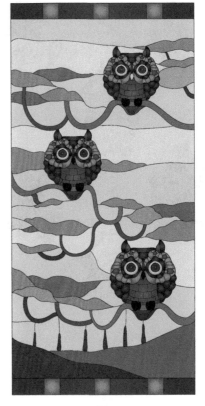

28

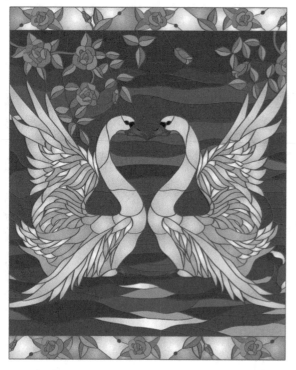

29

30

31

32

33

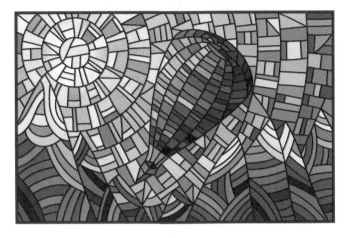

34

35

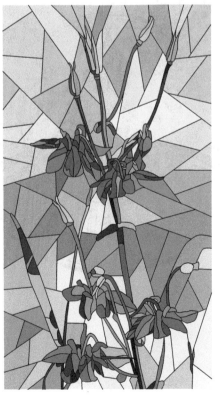

36

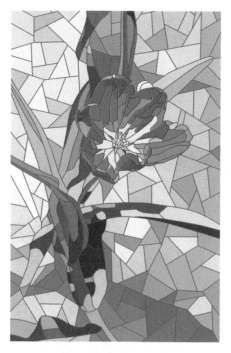

37

38

39

40

41

42

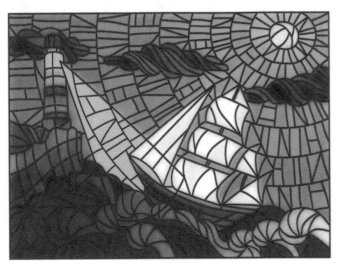

43

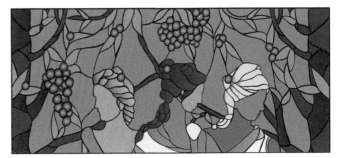

44

45

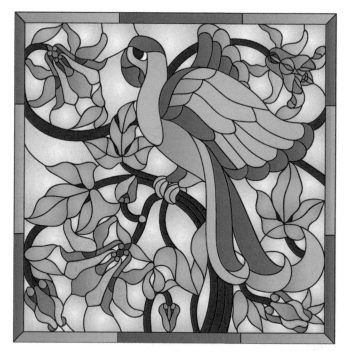

46

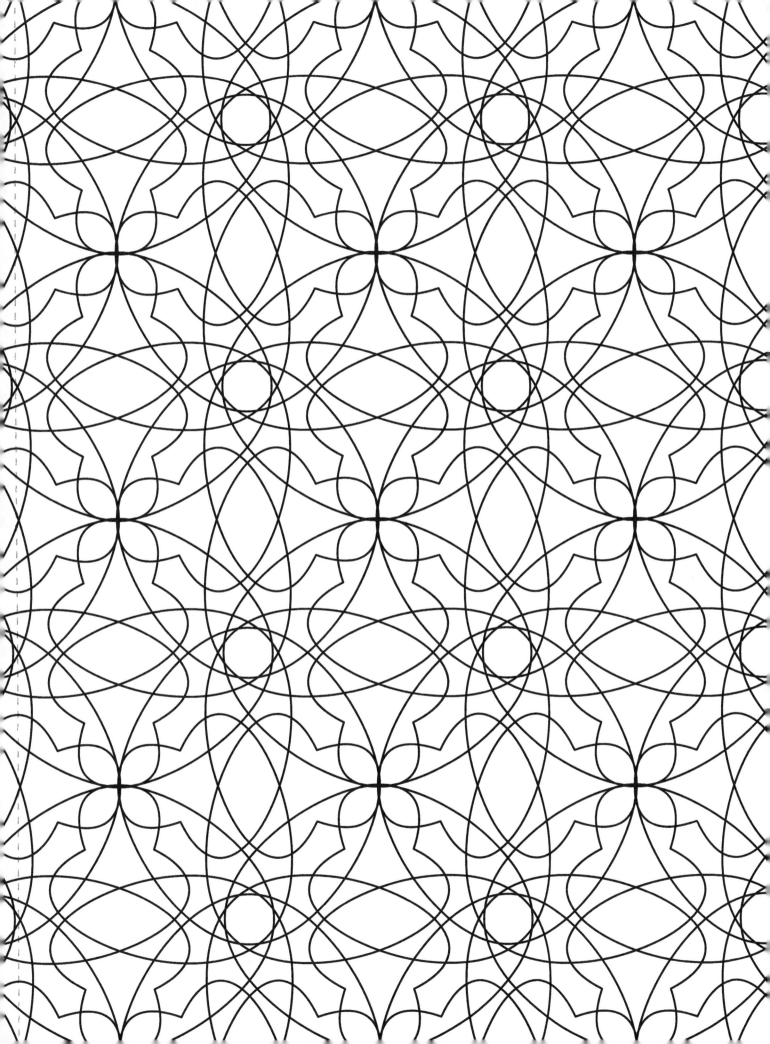

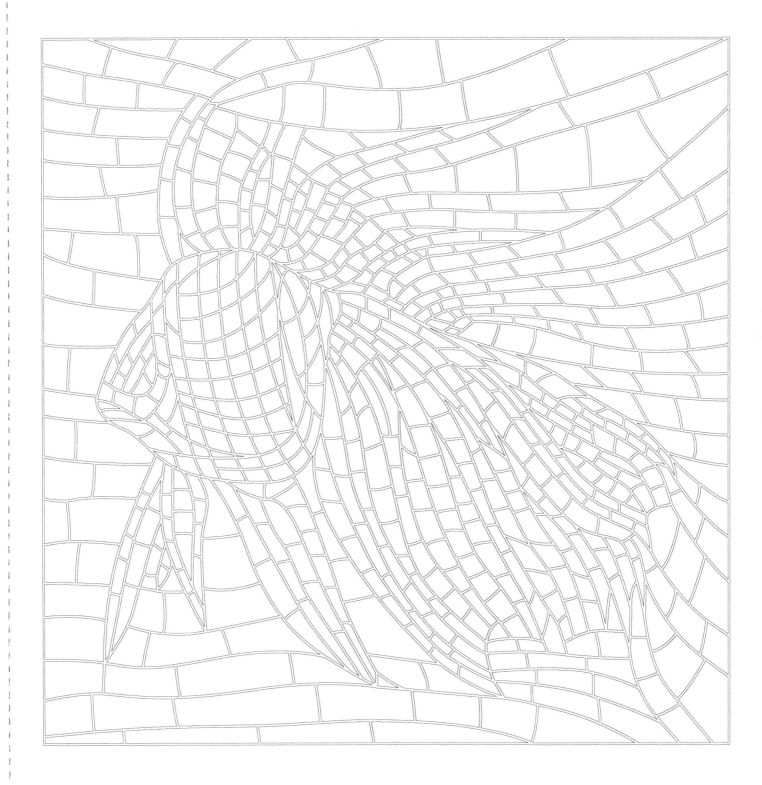

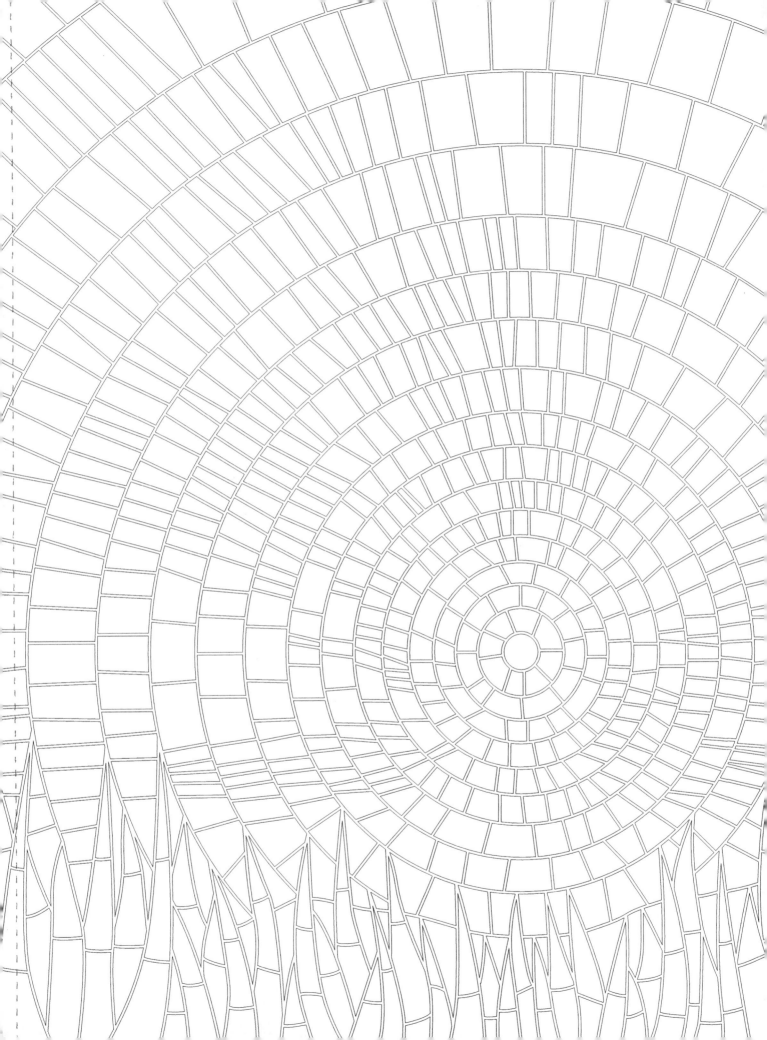

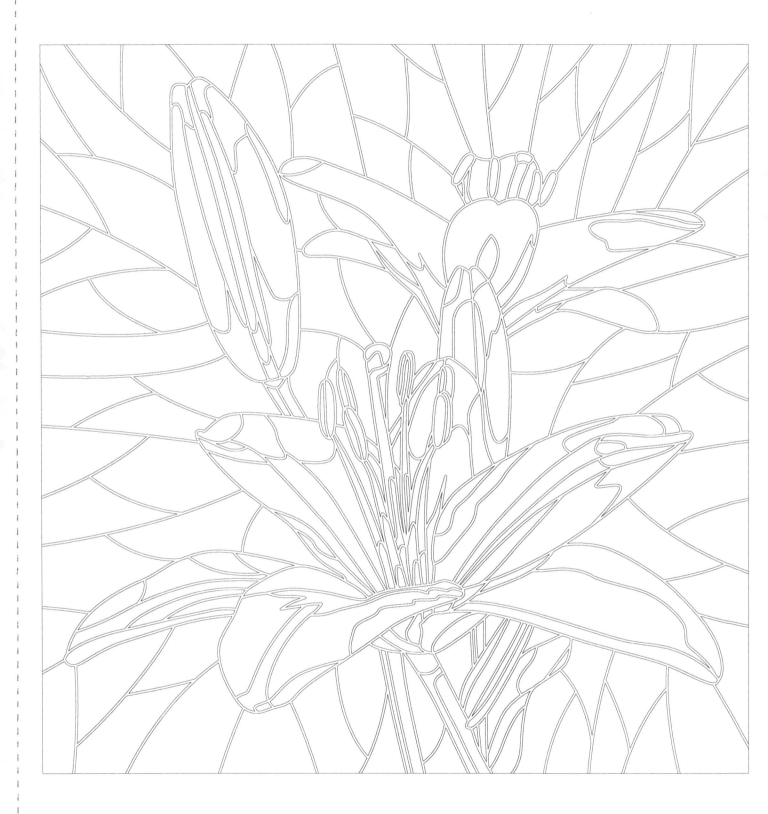

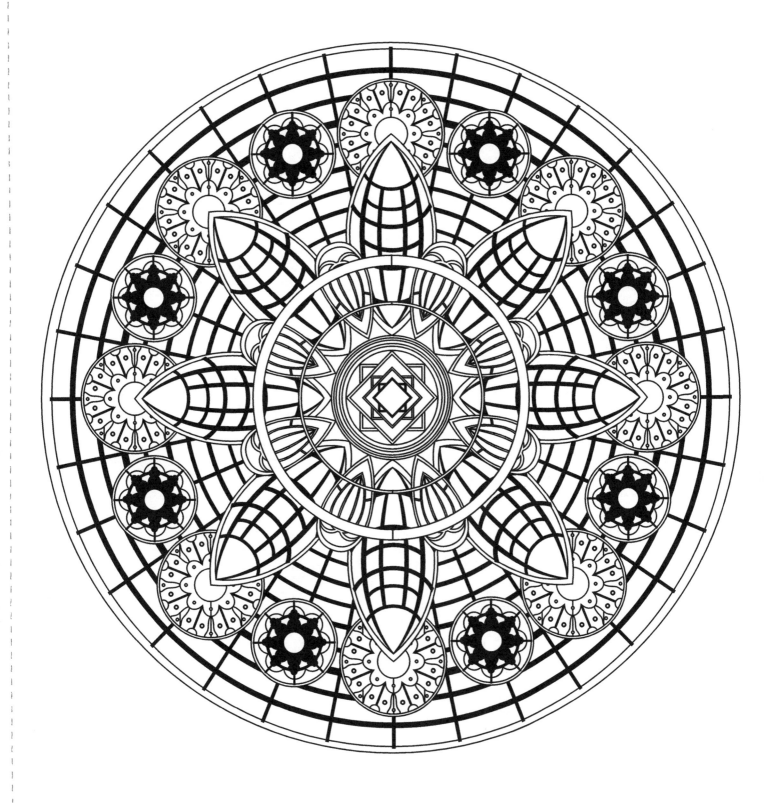

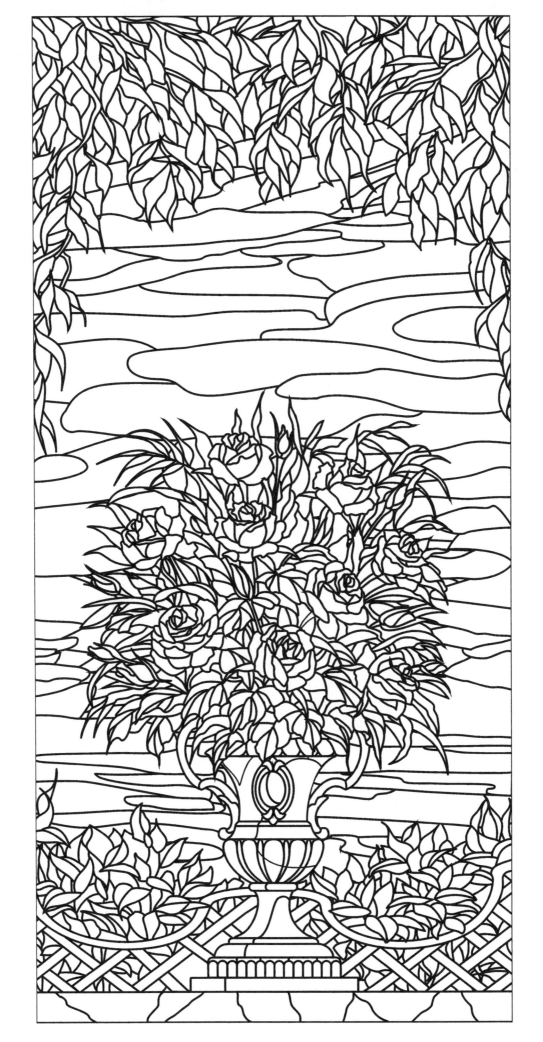

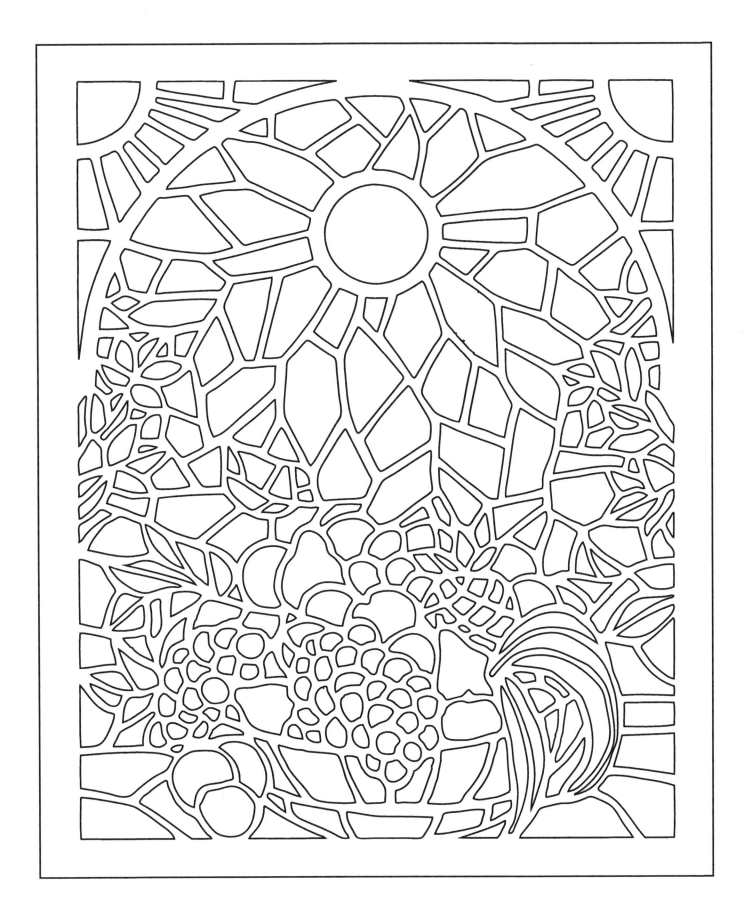

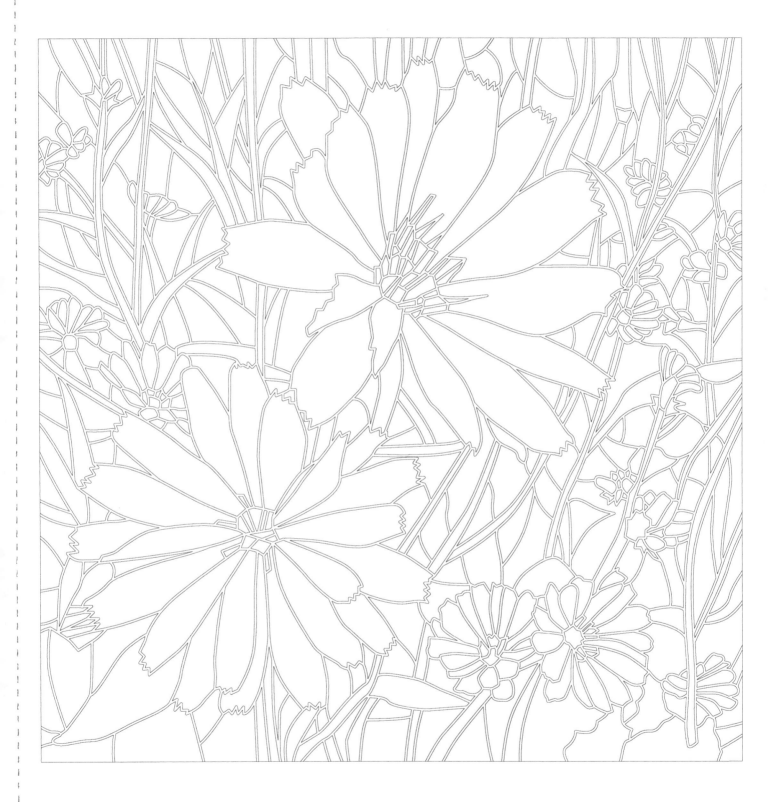

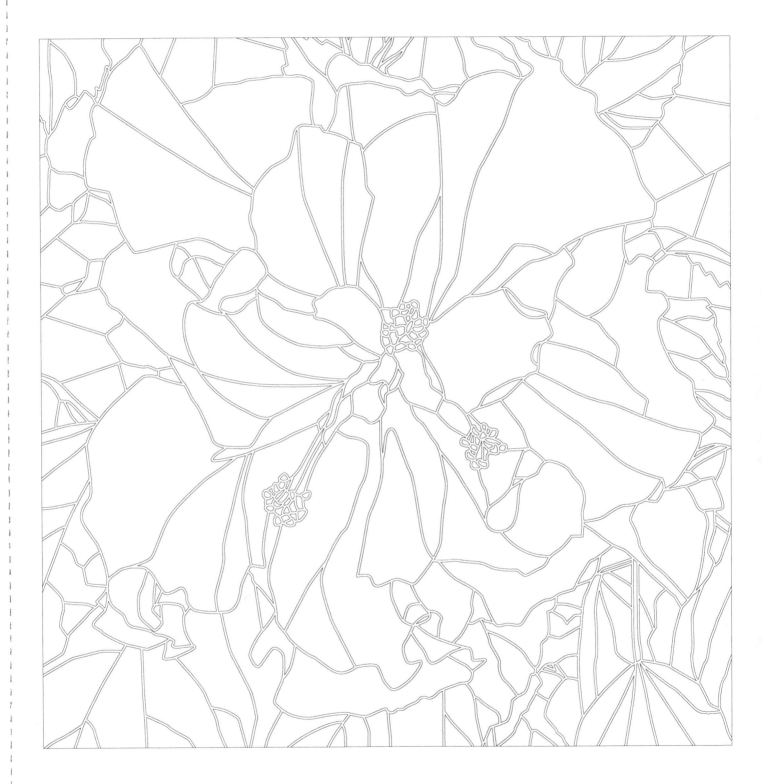

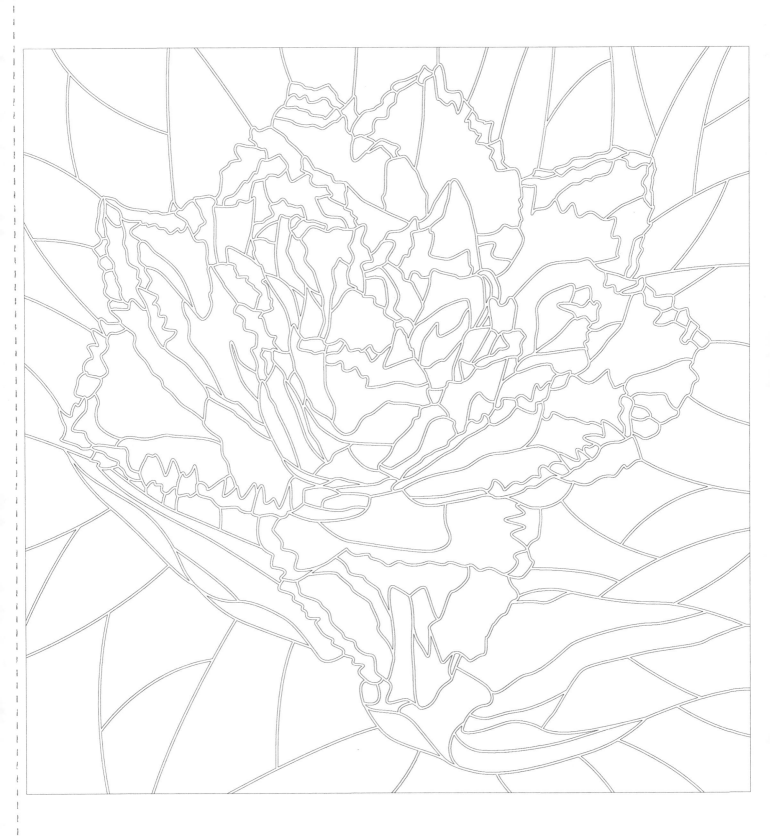

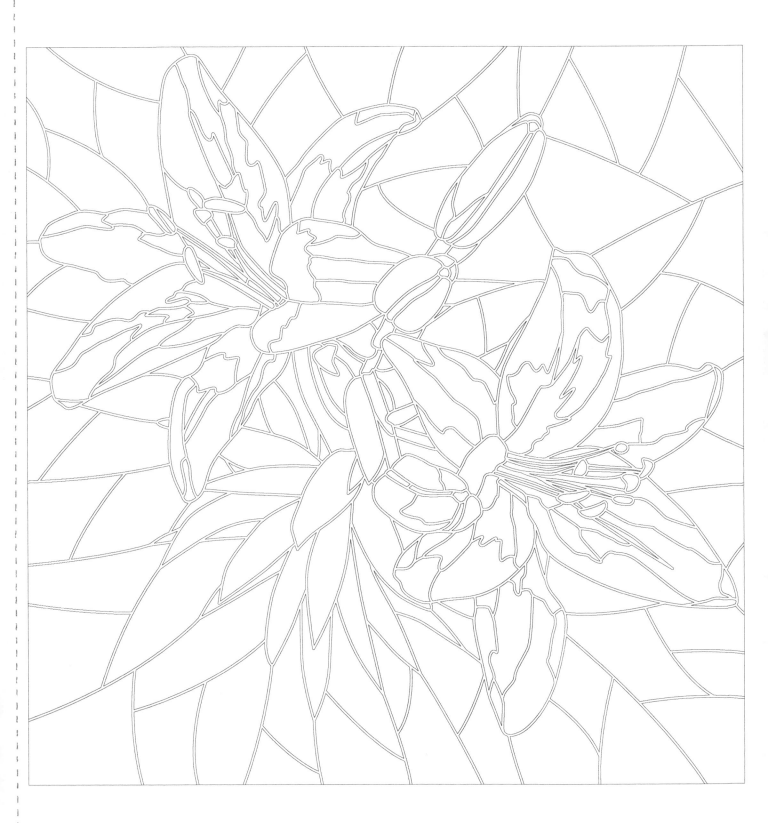

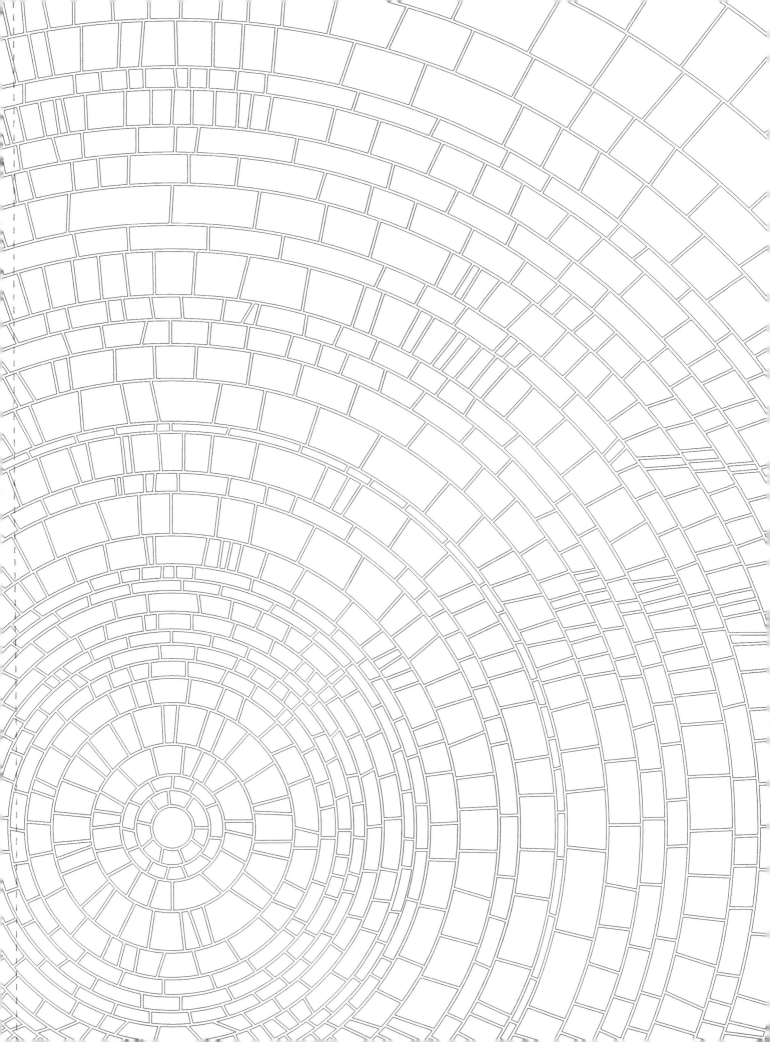

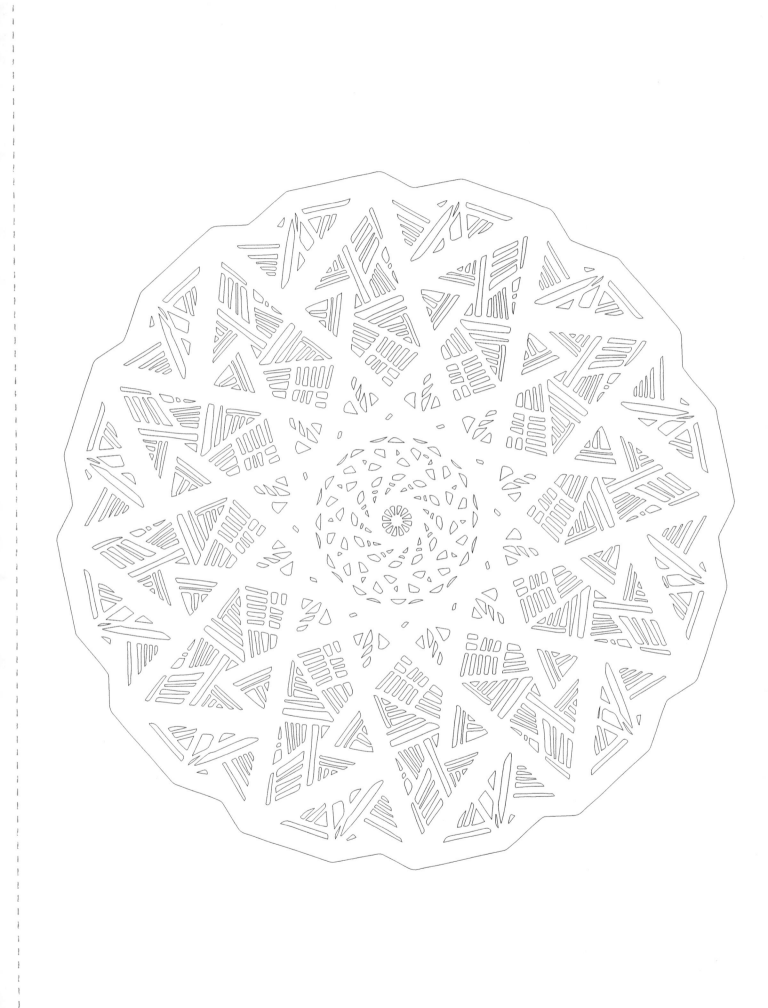

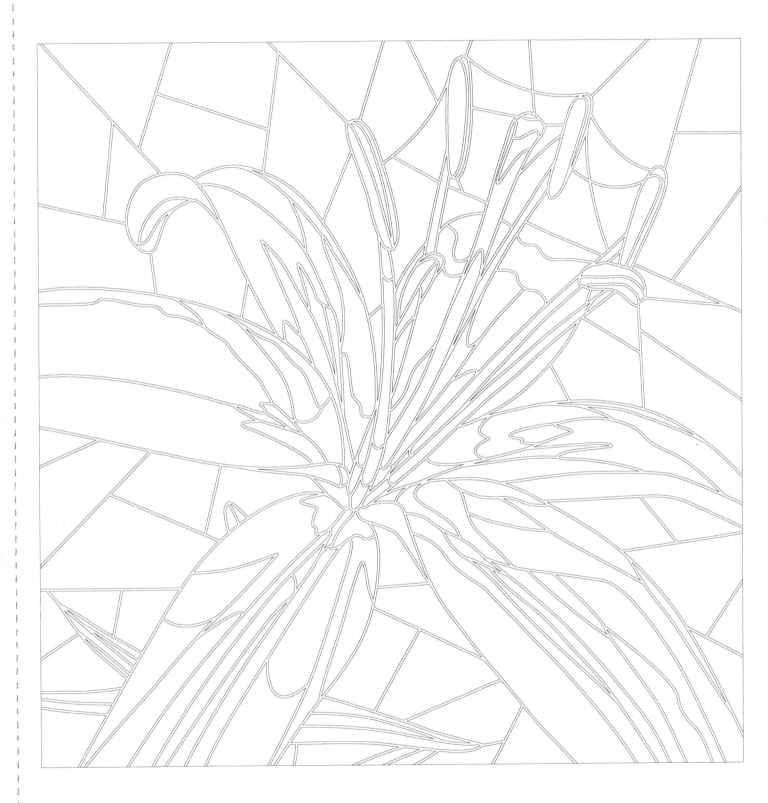

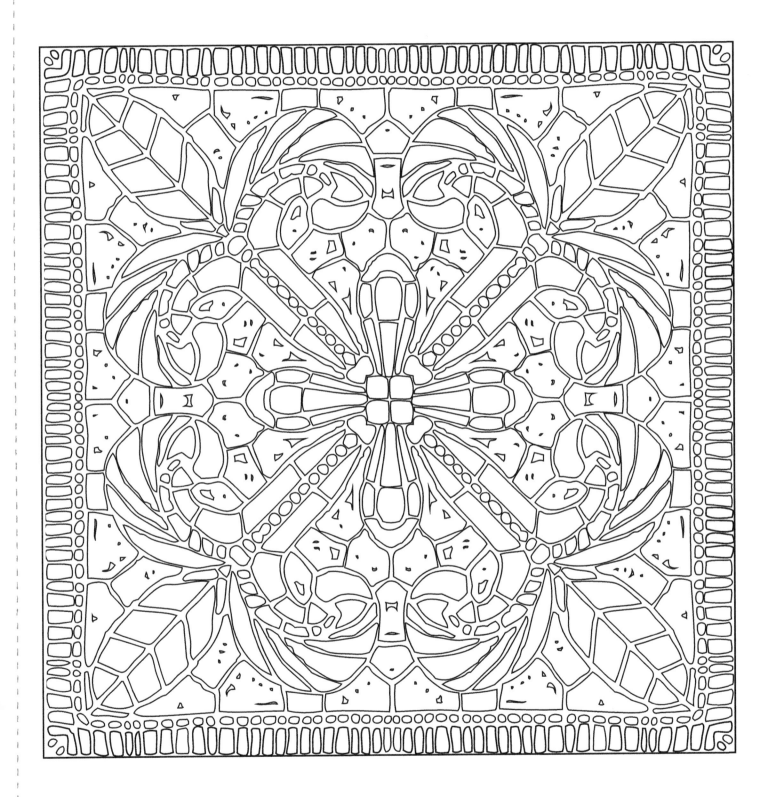

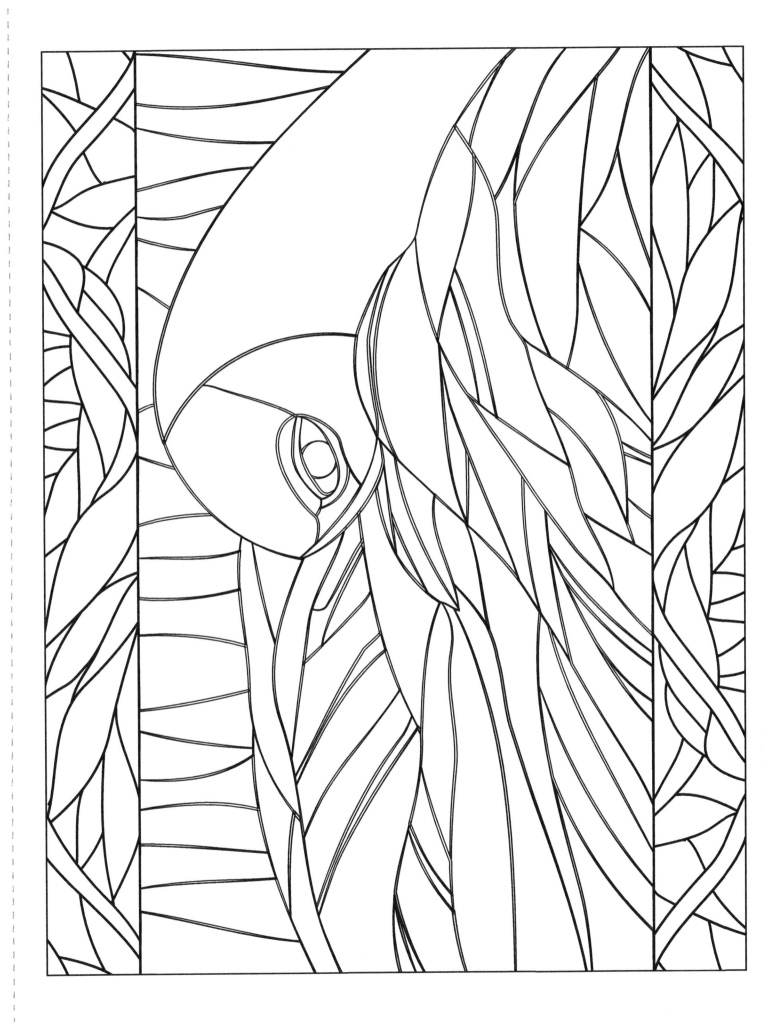

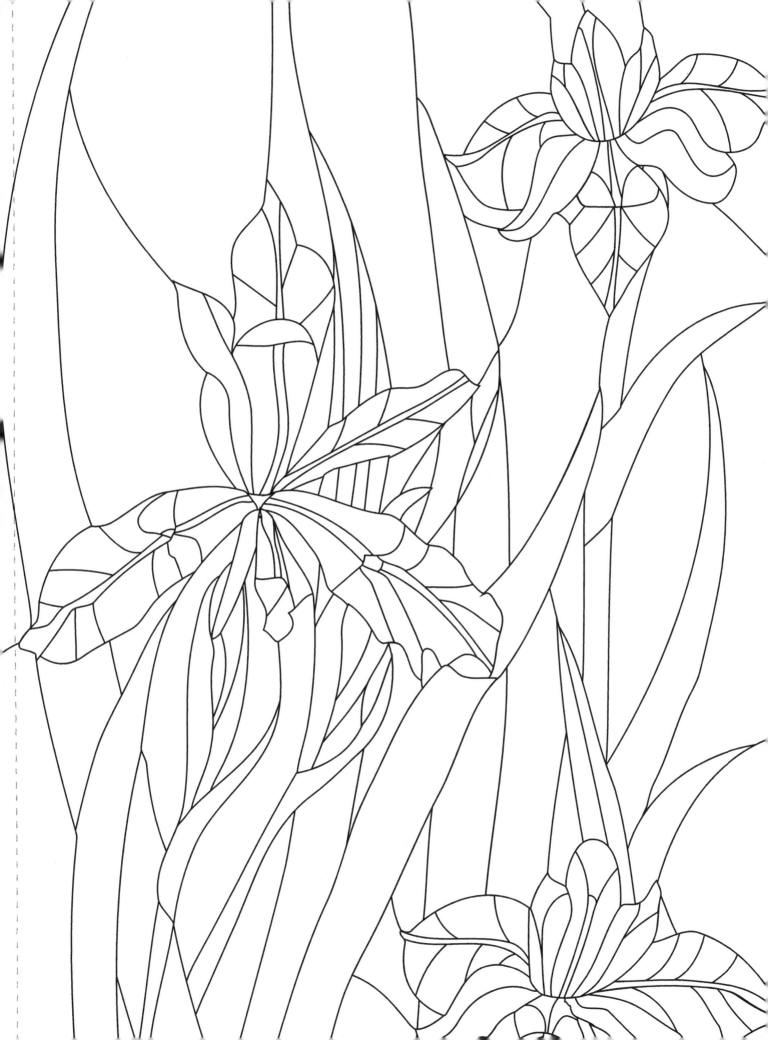

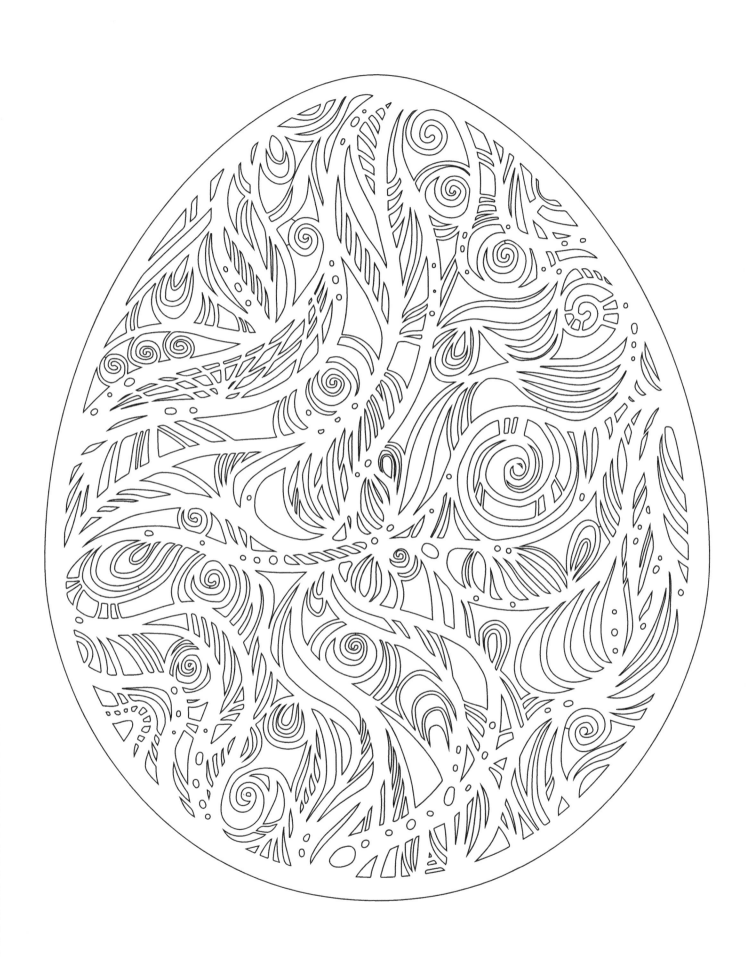

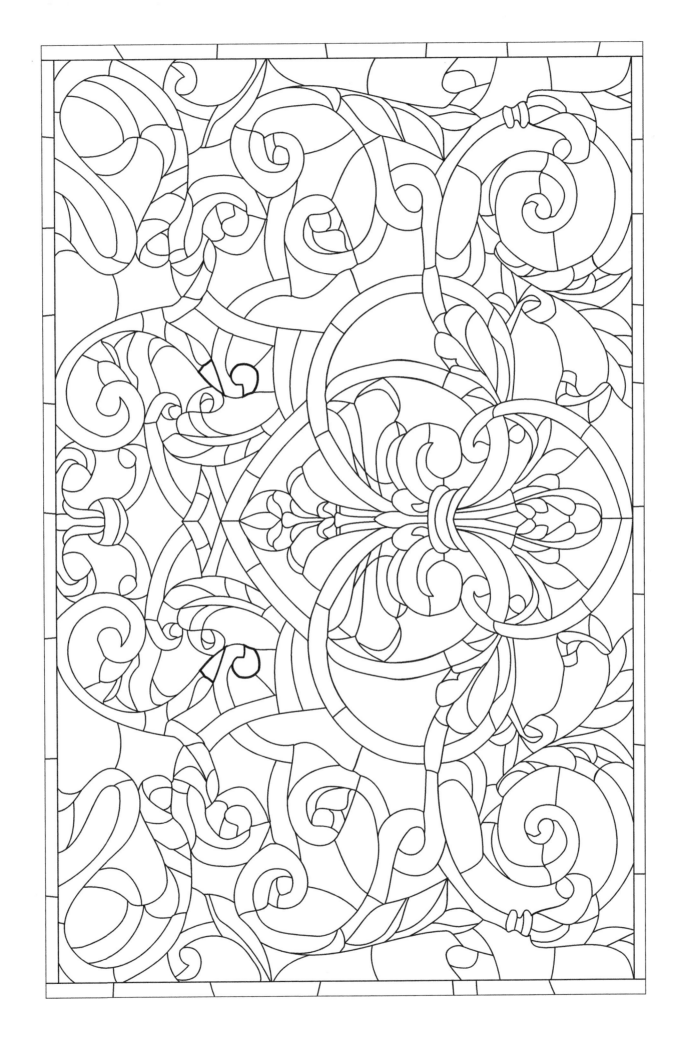

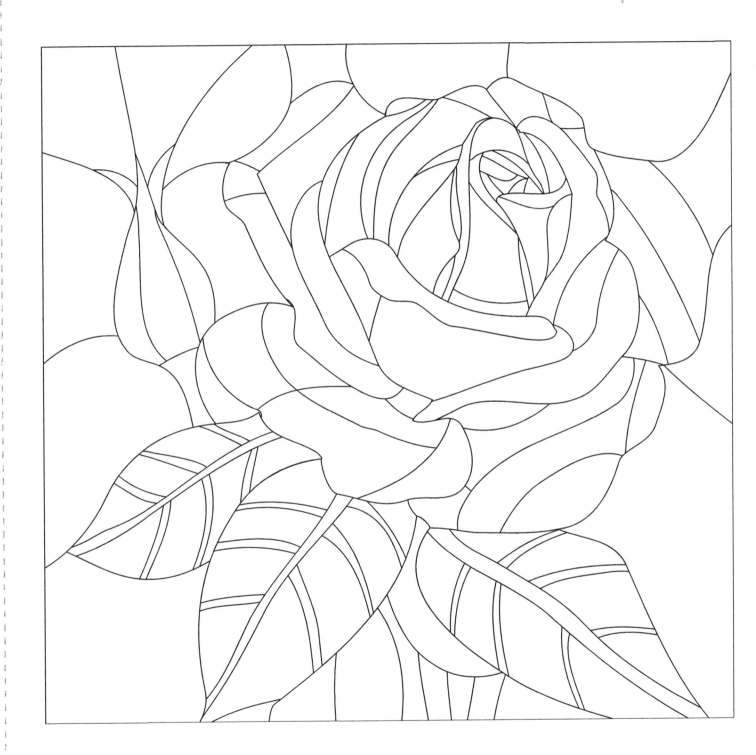

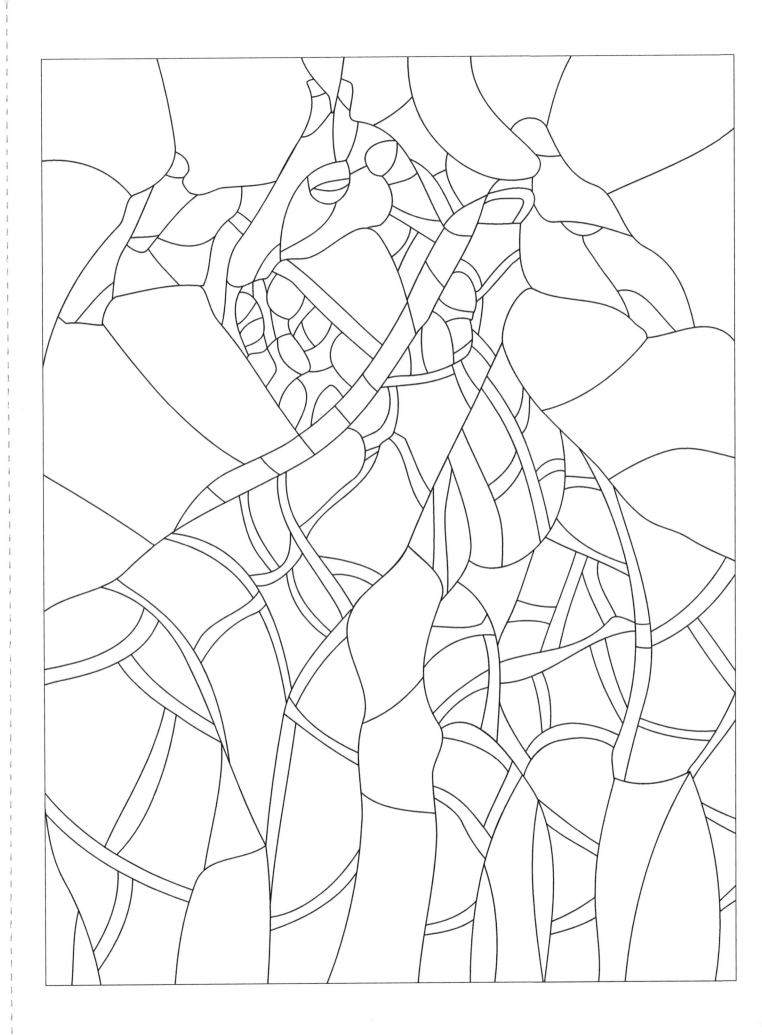

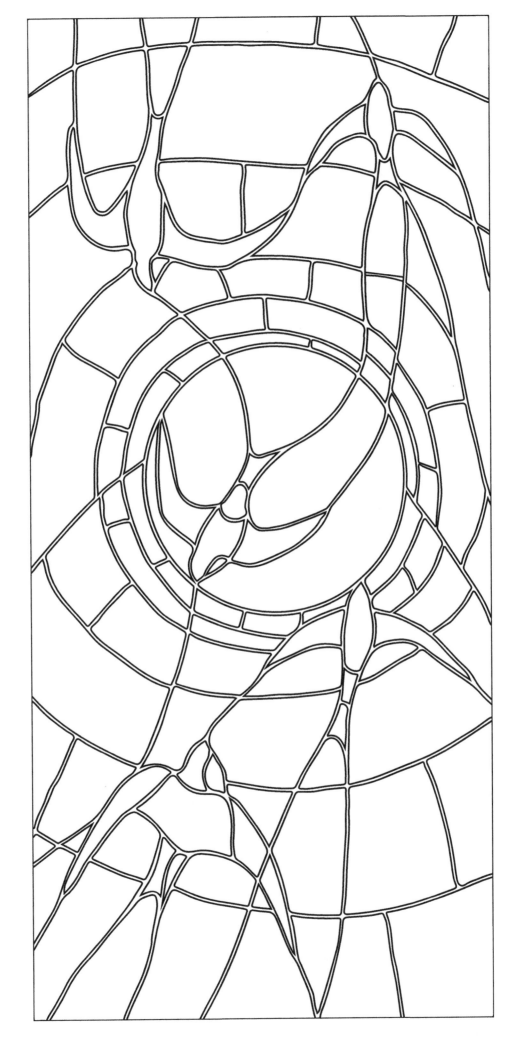

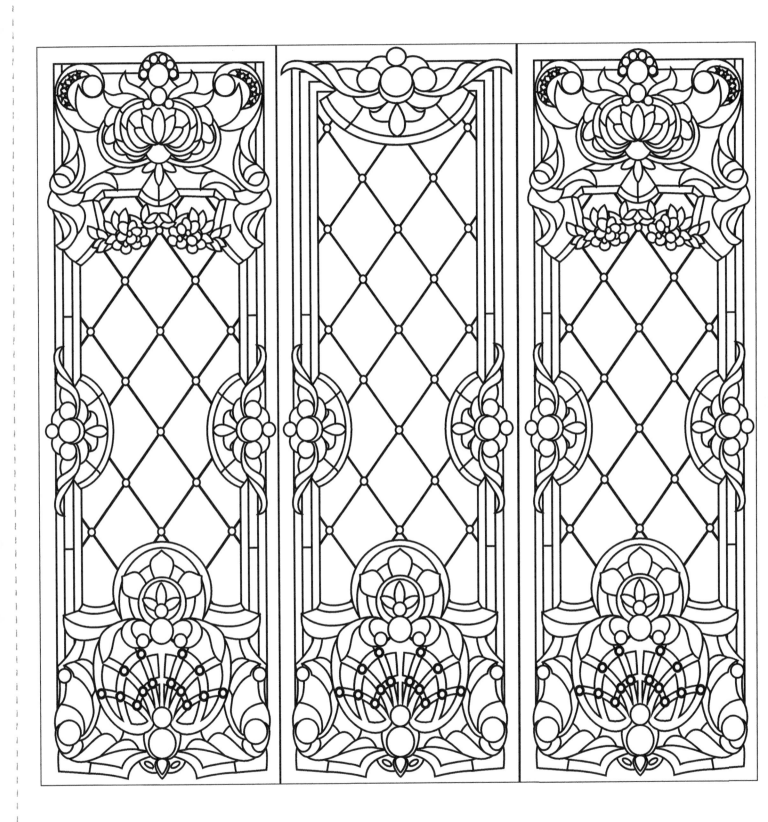

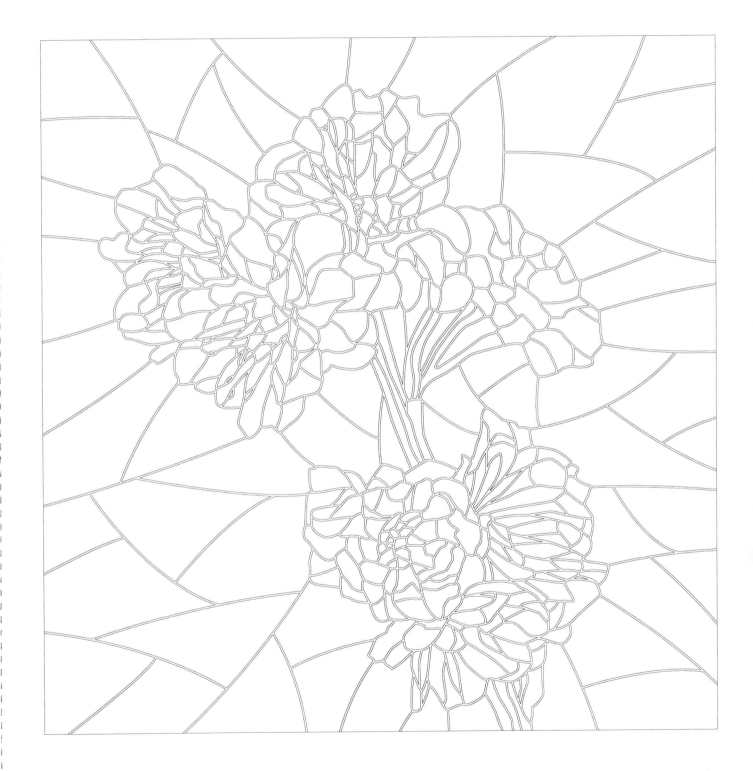

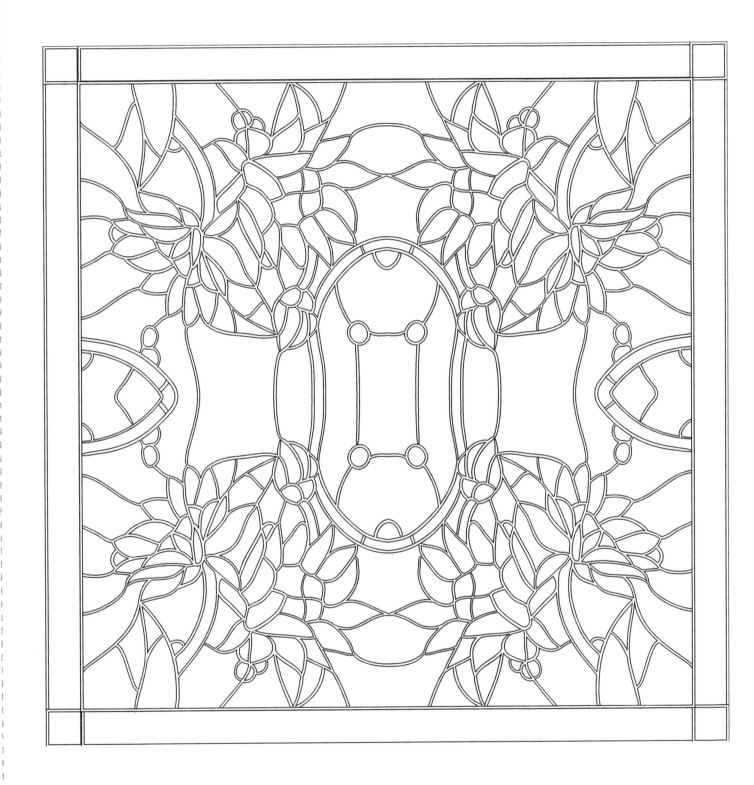

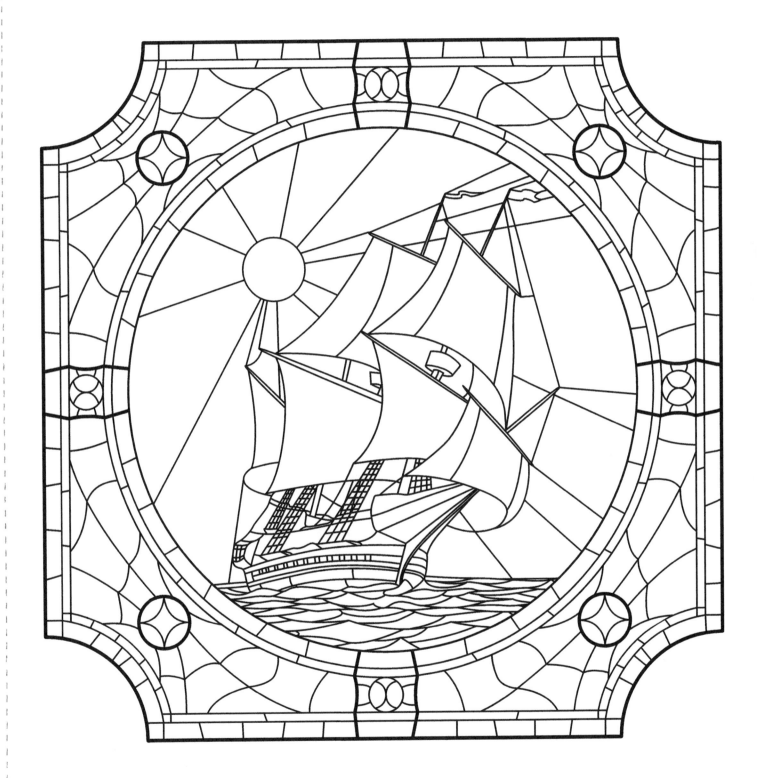

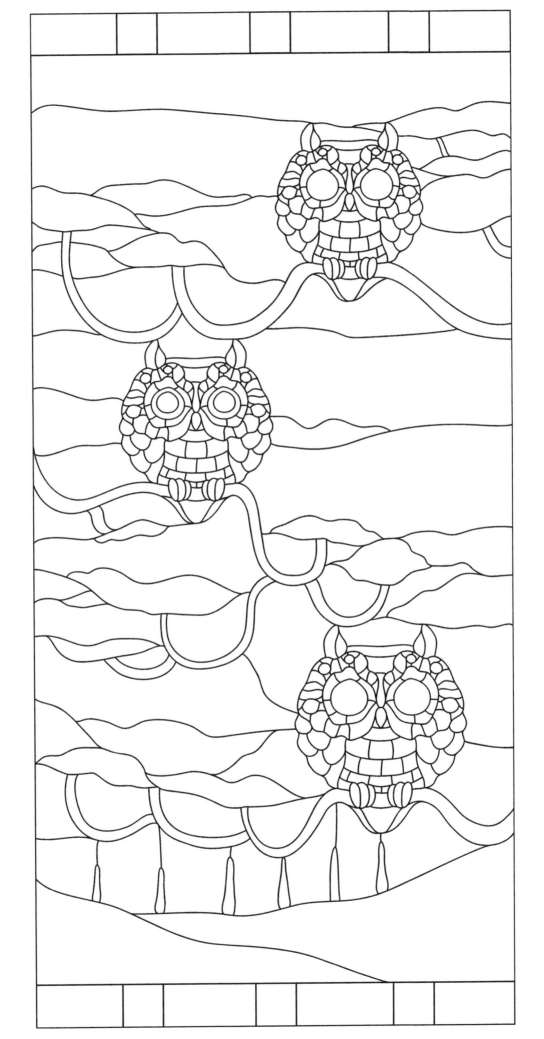

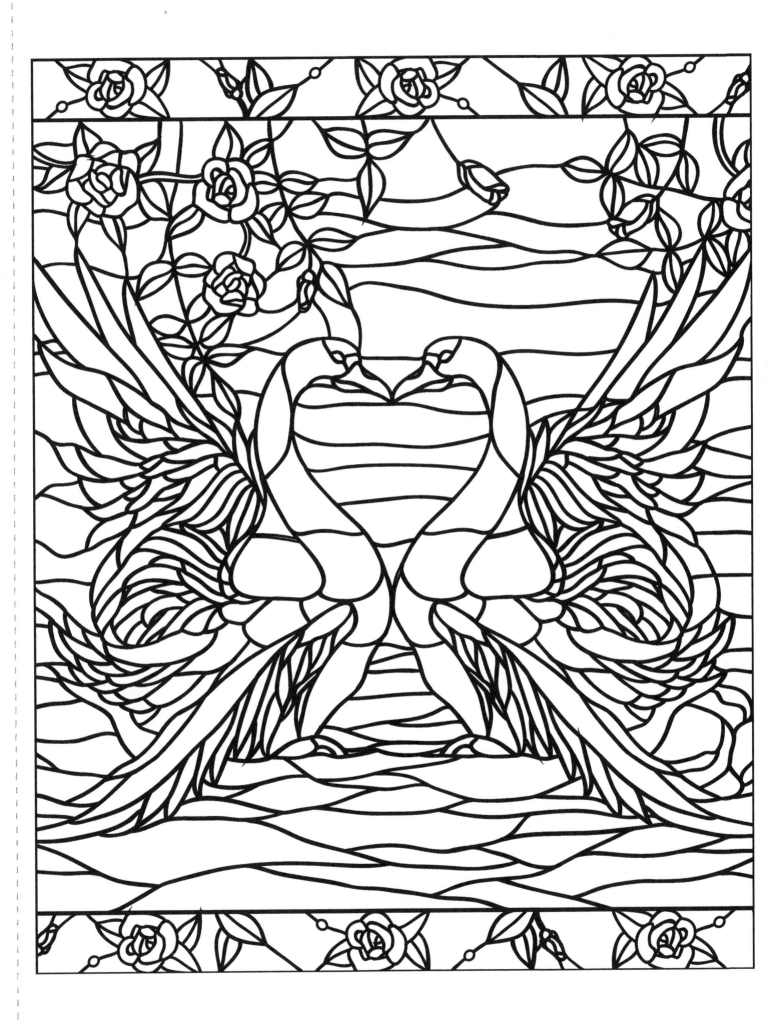

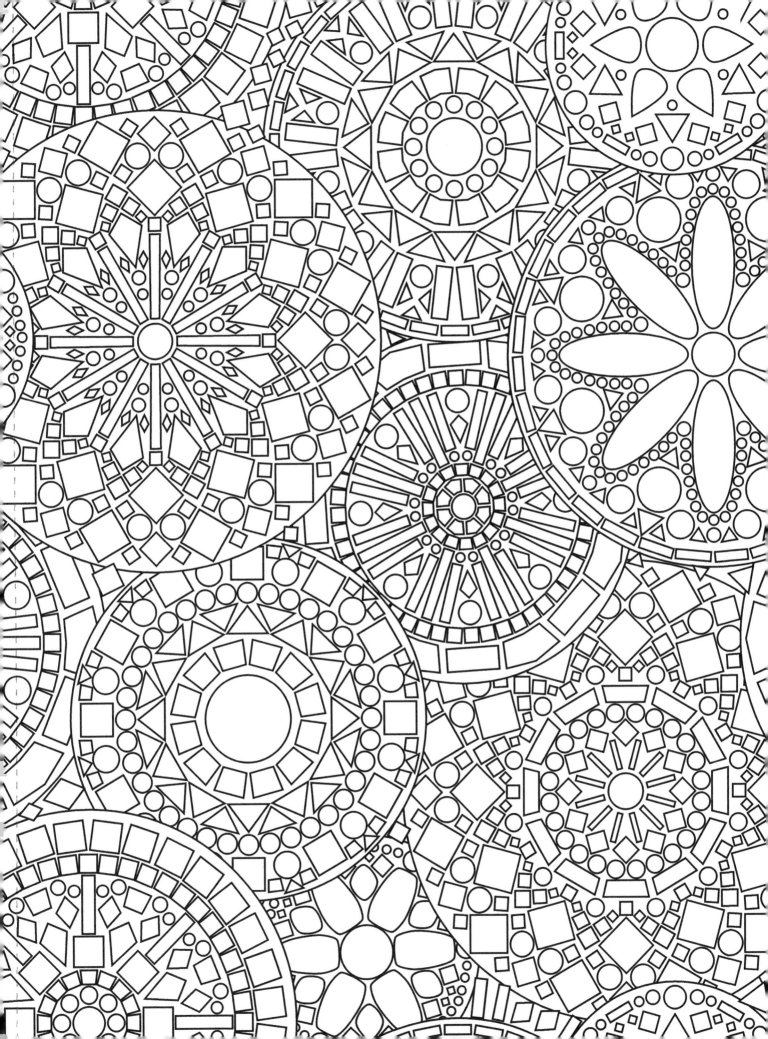

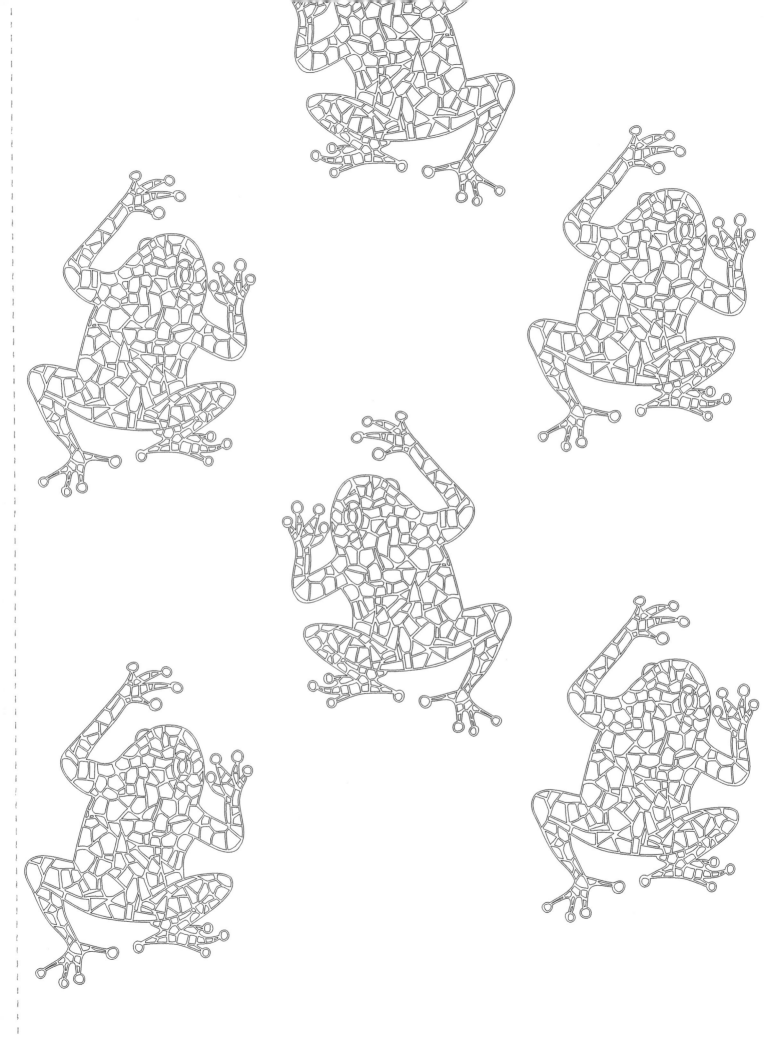

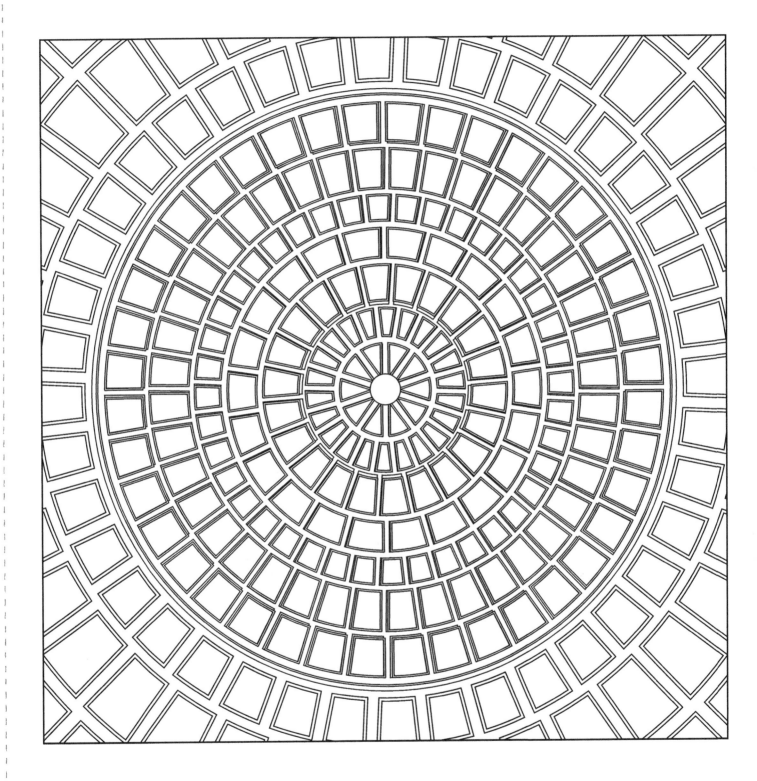

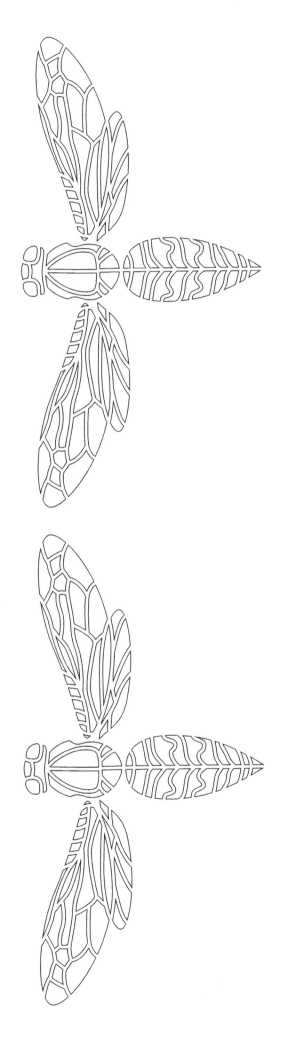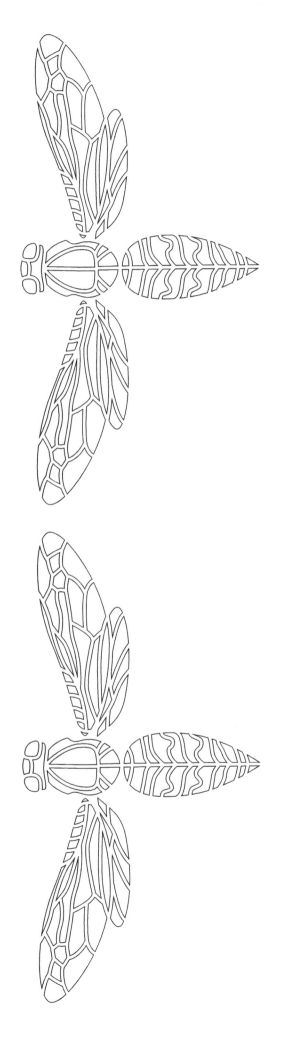

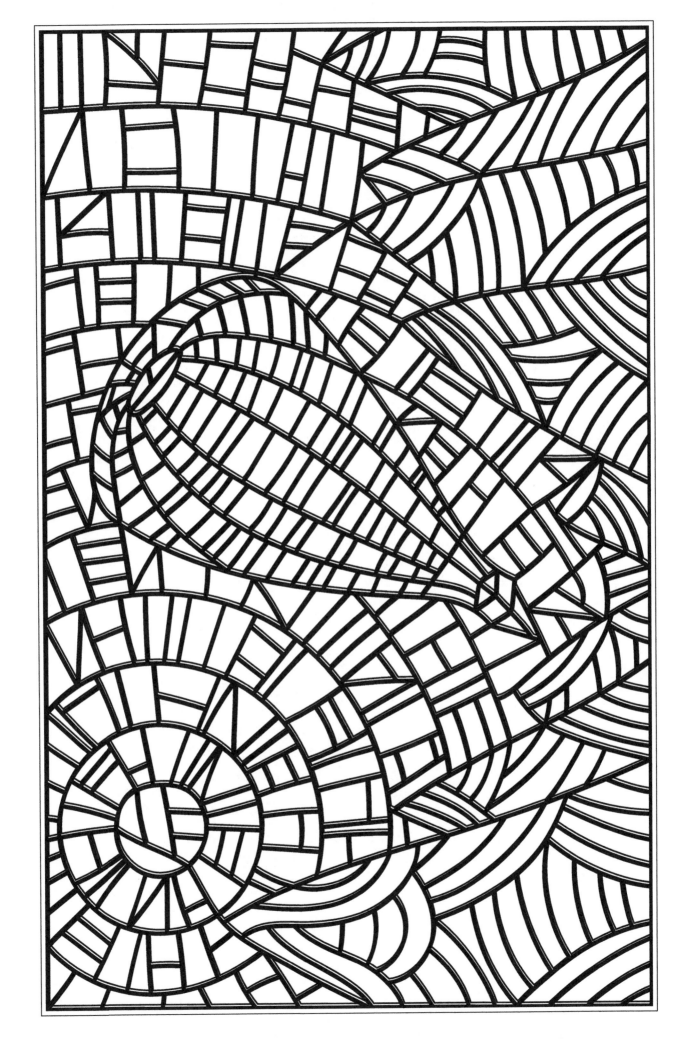

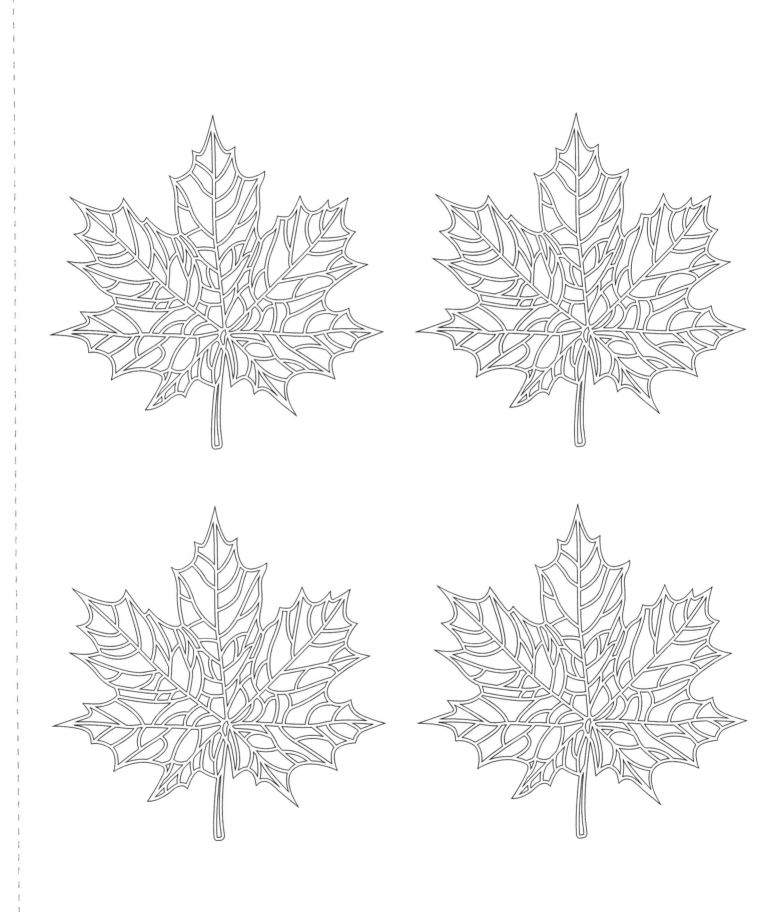

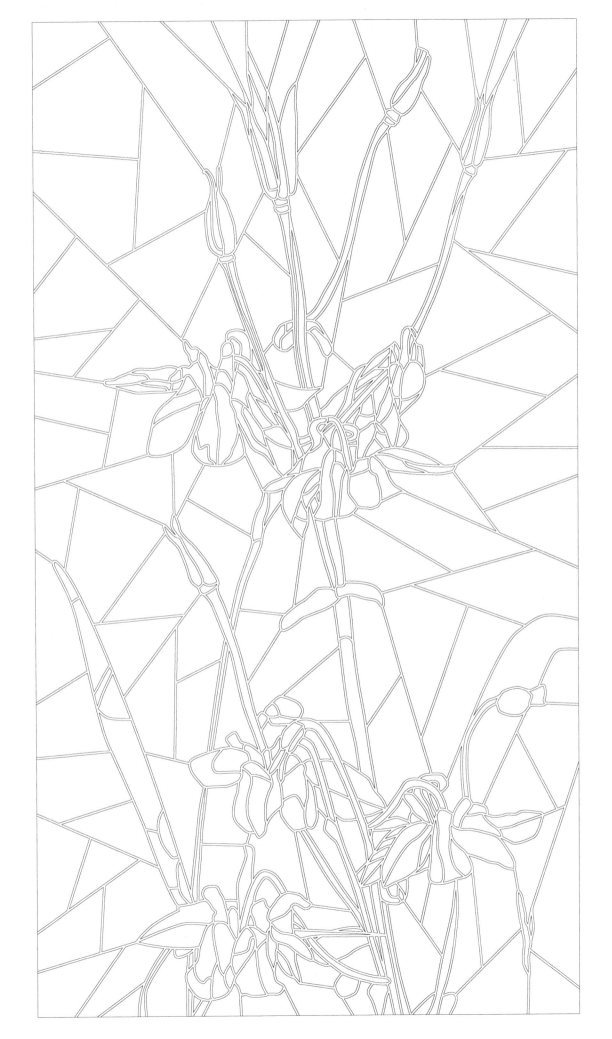

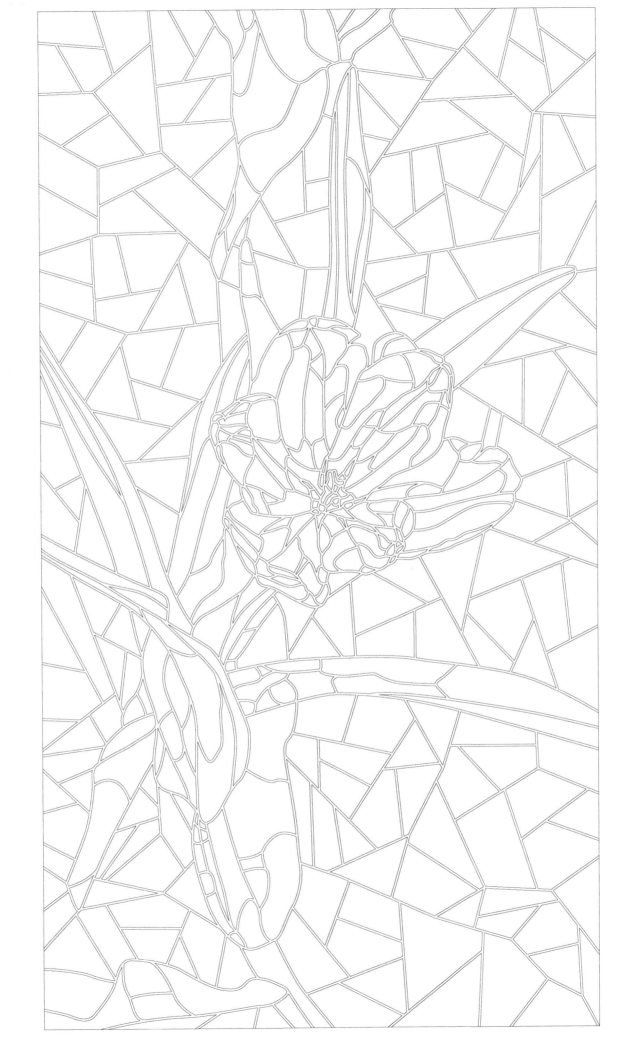

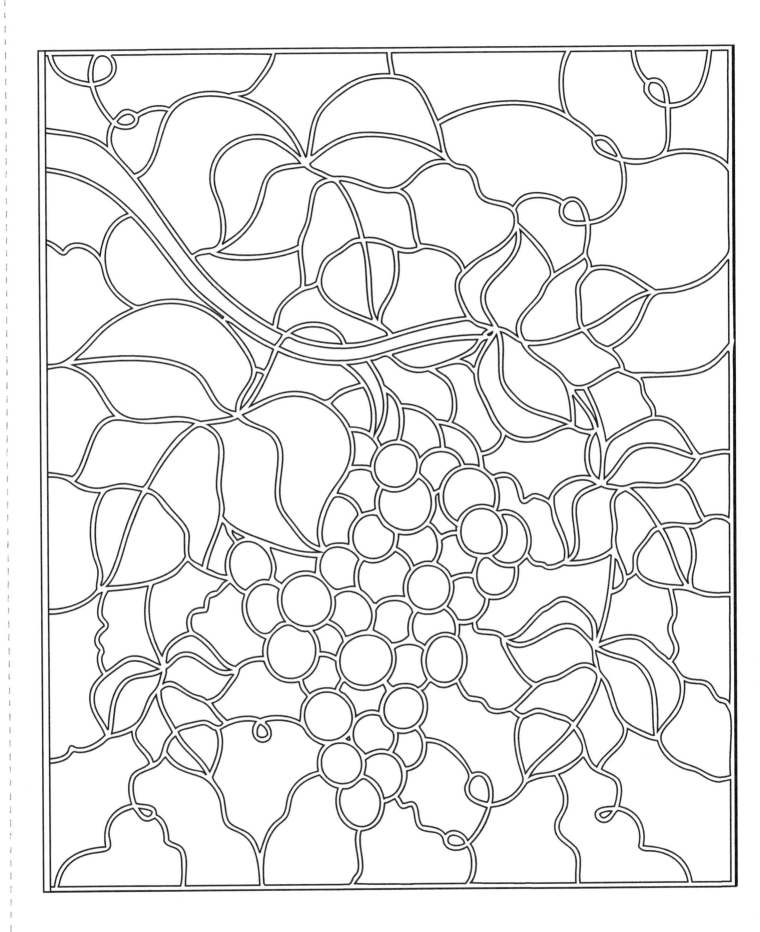

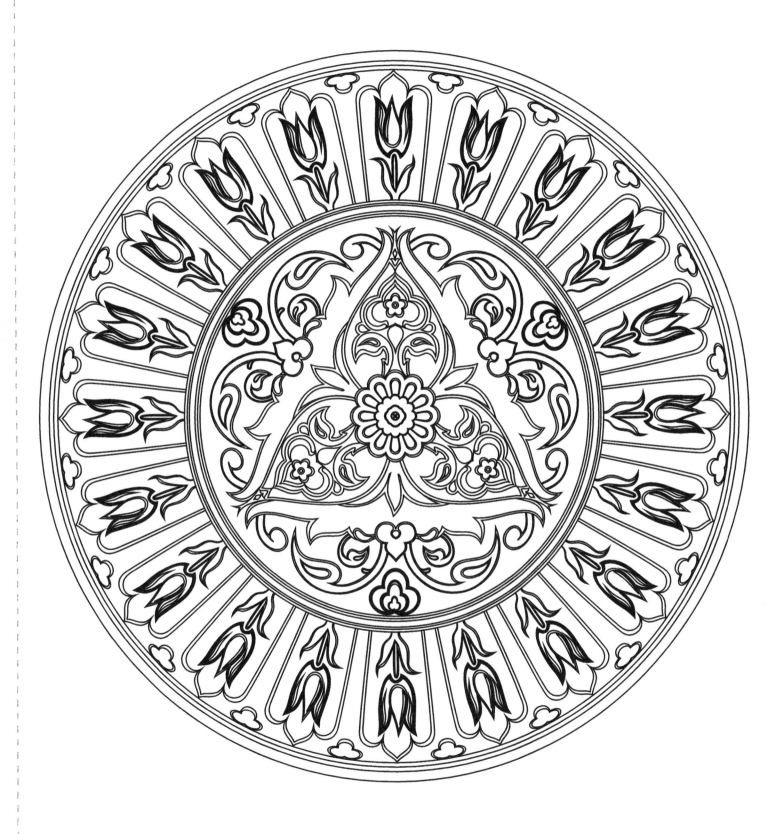

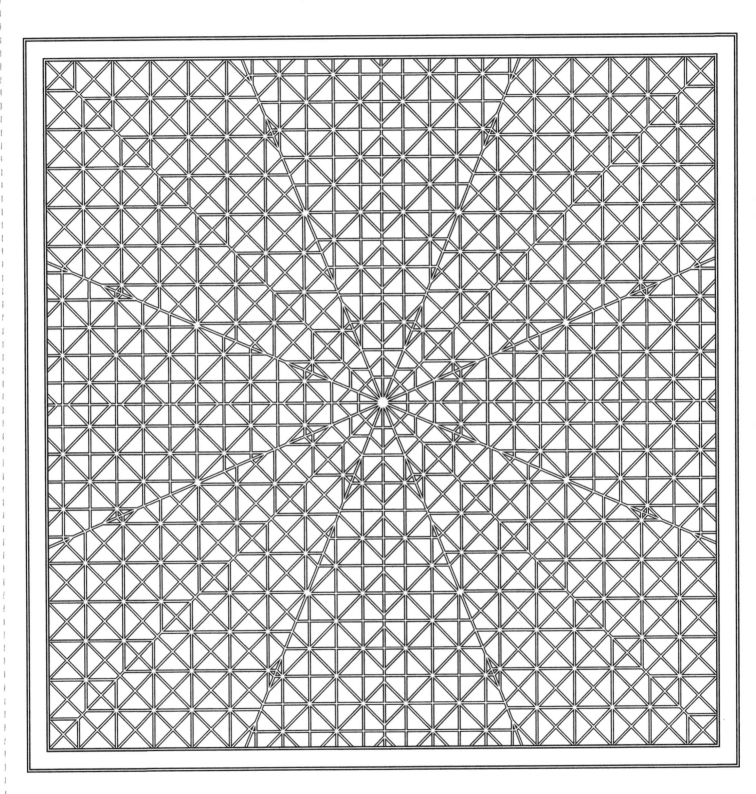

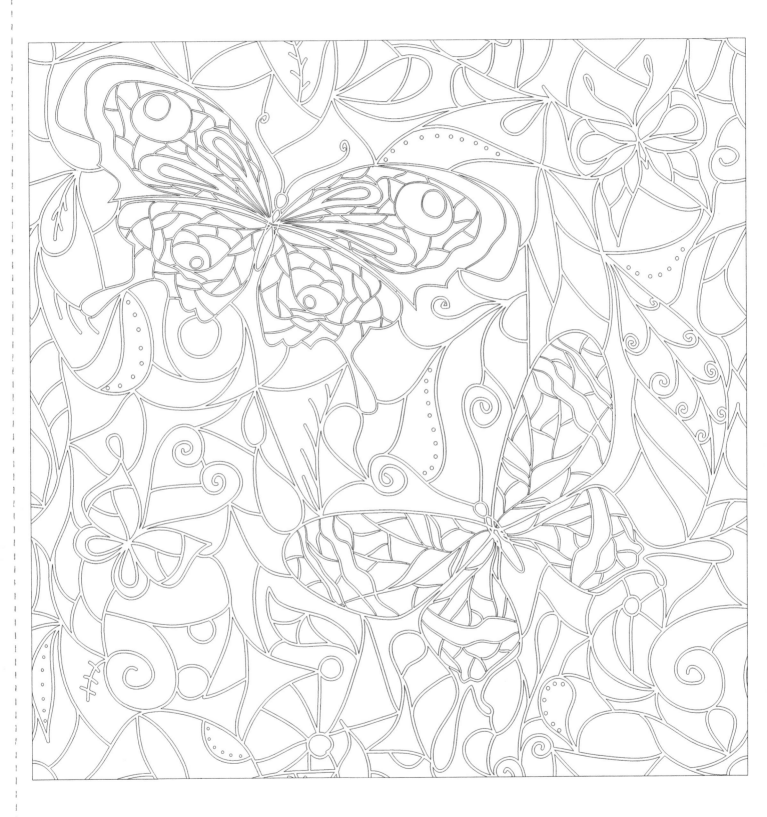

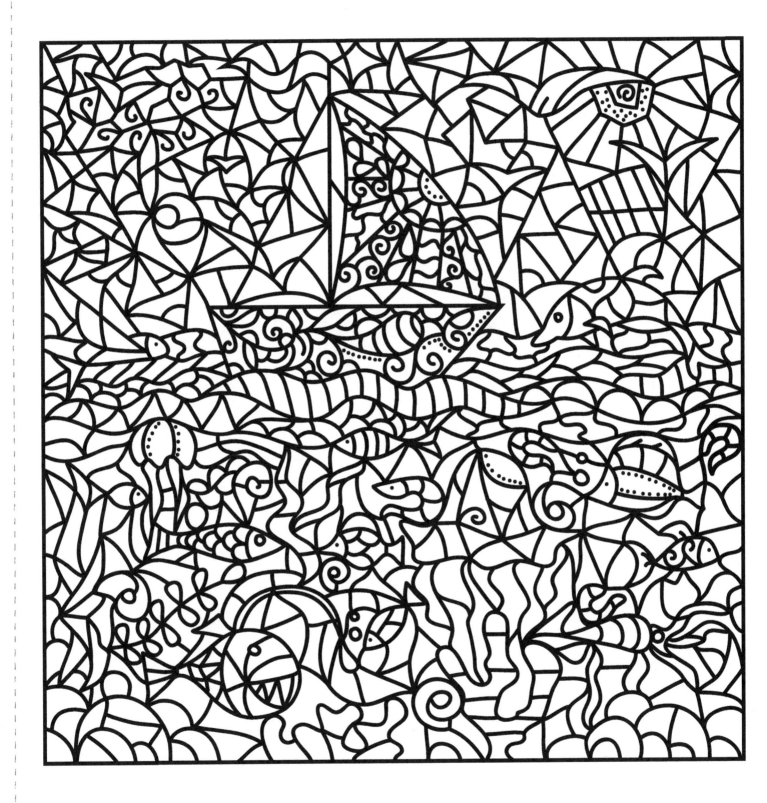

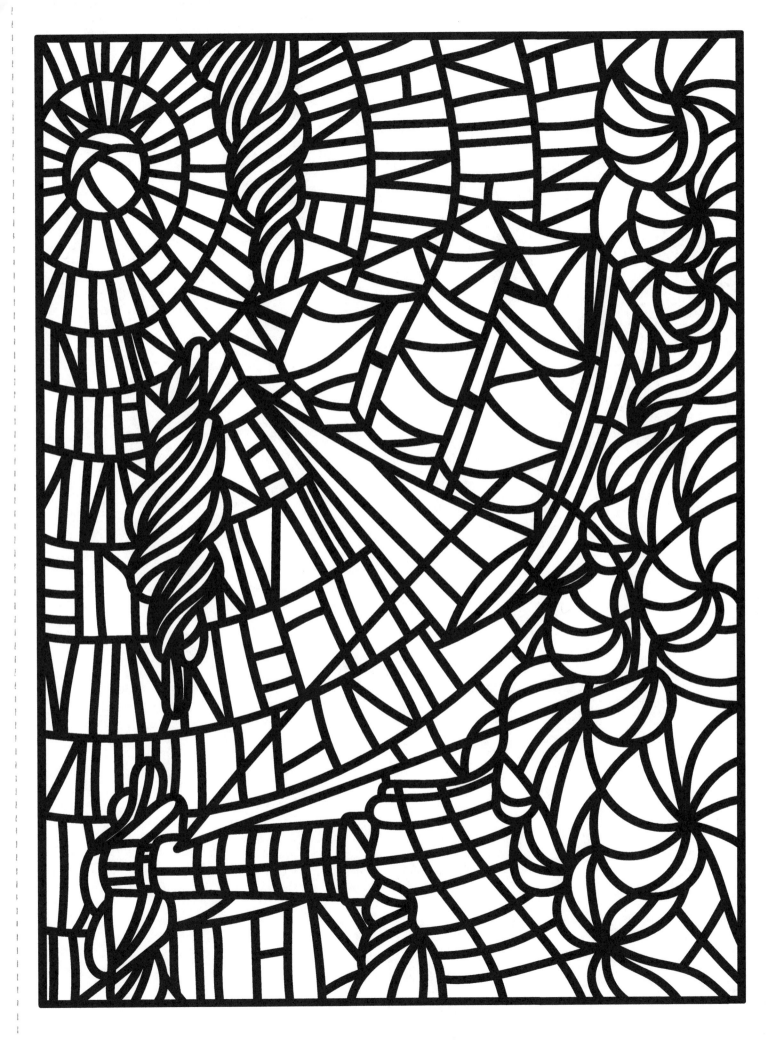

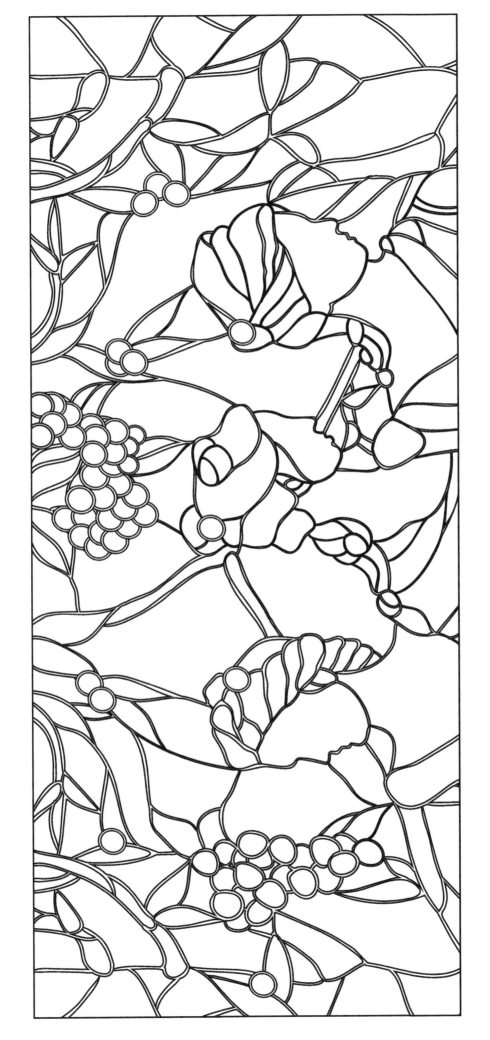

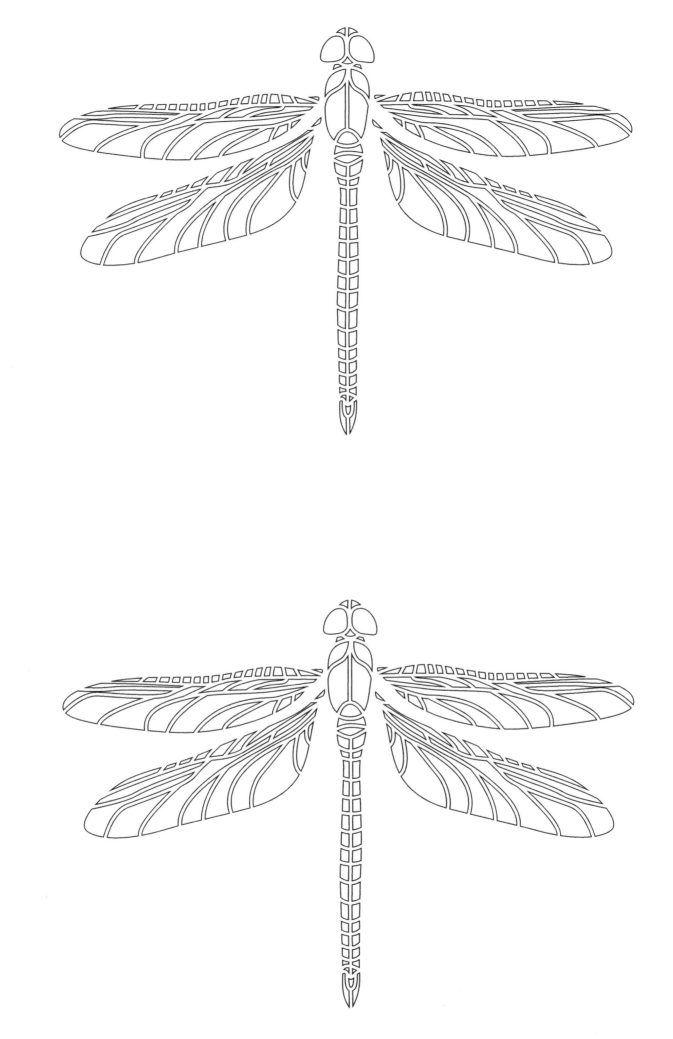

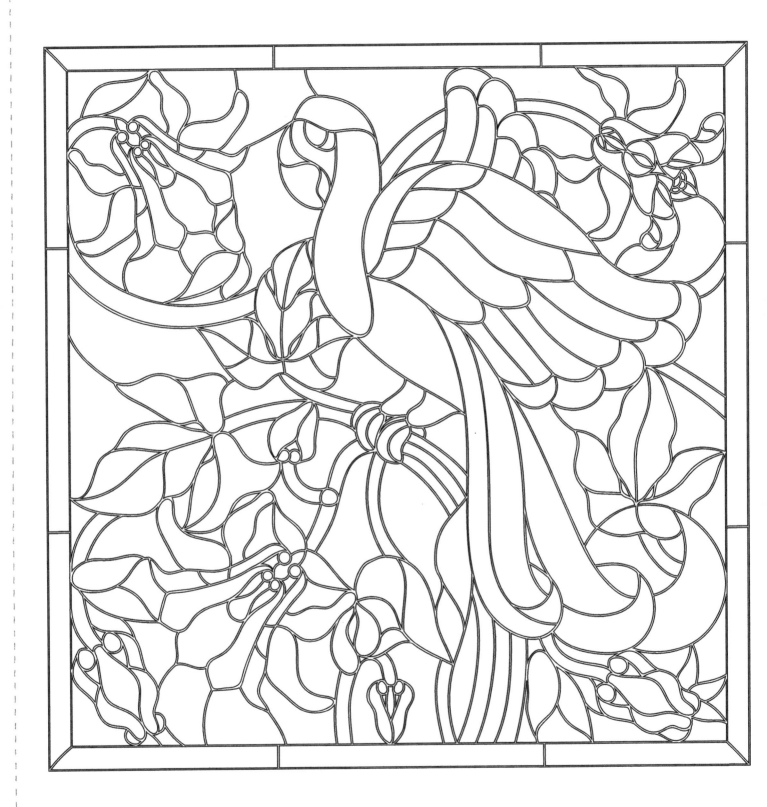

Color Bars

Use these bars to test your coloring medium and palette. Don't be afraid to try unique color combinations!

Color Bars

Color Bars

Also Available from Skyhorse Publishing

Creative Stress Relieving Adult Coloring Book Series
Art Nouveau: Coloring for Artists
Art Nouveau: Coloring for Everyone
Butterfly Gardens: Coloring for Everyone
Curious Cats and Kittens: Coloring for Artists
Curious Cats and Kittens: Coloring for Everyone
Exotic Chickens: Coloring for Everyone
Mandalas: Coloring for Artists
Mandalas: Coloring for Everyone
Mehndi: Coloring for Artists
Mehndi: Coloring for Everyone
Moroccan Motifs: Coloring for Artists
Moroccan Motifs: Coloring for Everyone
Nature's Wonders: Coloring for Everyone
Nirvana: Coloring for Artists
Nirvana: Coloring for Everyone
Paisleys: Coloring for Artists
Paisleys: Coloring for Everyone
Tapestries, Fabrics, and Quilts: Coloring for Artists
Tapestries, Fabrics, and Quilts: Coloring for Everyone
Whimsical Designs: Coloring for Artists
Whimsical Designs: Coloring for Everyone
Whimsical Woodland Creatures: Coloring for Artists
Whimsical Woodland Creatures: Coloring for Everyone
Zen Patterns and Designs: Coloring for Artists
Zen Patterns and Designs: Coloring for Everyone

New York Times Bestselling Artists' Adult Coloring Book Series
Marty Noble's Sugar Skulls
Marty Noble's Peaceful World
Marjorie Sarnat's Fanciful Fashions
Marjorie Sarnat's Pampered Pets

The Peaceful Adult Coloring Book Series
Adult Coloring Book: Be Inspired
Adult Coloring Book: De-Stress
Adult Coloring Book: Keep Calm
Adult Coloring Book: Relax

Portable Coloring for Creative Adults
Calming Patterns: Portable Coloring for Creative Adults
Flying Wonders: Portable Coloring for Creative Adults
Natural Wonders: Portable Coloring for Creative Adults
Sea Life: Portable Coloring for Creative Adults